8-6-2013

Melyssa -

I hope you enjoy reading
about Jackie, she was so inspirational
to me when I was your age.
Papa & I hope your recovery will
be quick & painless!

Love you so!

Nana

XXXX OOOO

Remembering
Jackie

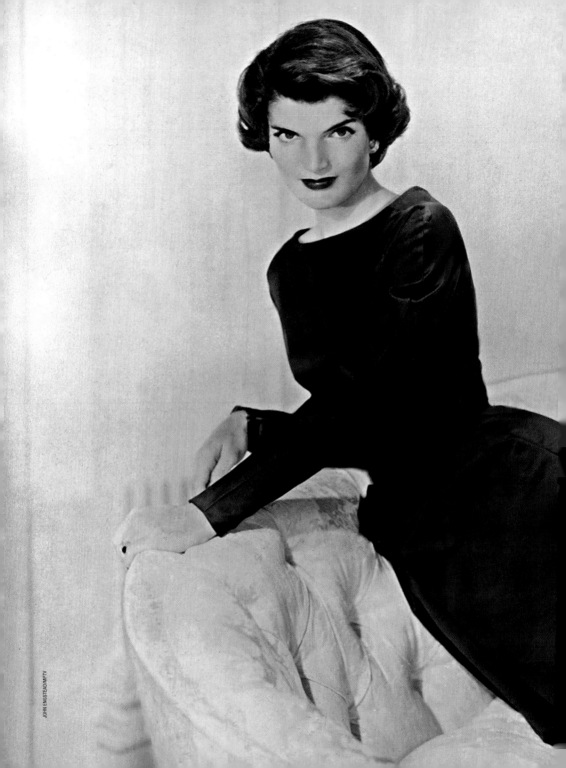

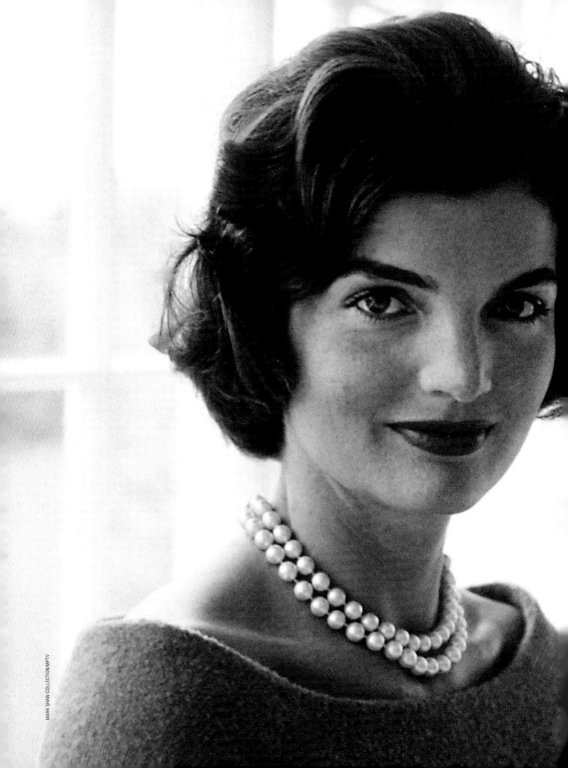

Remembering
Jackie

LIFE Books

EDITOR Robert Sullivan
DIRECTOR OF PHOTOGRAPHY Barbara Baker Burrows
ART DIRECTOR Rick DeMonico
DEPUTY PICTURE EDITOR Christina Lieberman
ASSOCIATE PICTURE EDITOR Arnold Horton
WRITER-REPORTER Hildegard Anderson
COPY EDITOR Christopher Sweet
PHOTO ASSISTANT Forrester Hambrecht
CONSULTING PICTURE EDITORS Mimi Murphy (Rome),
Tala Skari (Paris)

STAFF FOR THE ORIGINAL 1994 EDITION
LIFE EDITOR Daniel Okrent
LIFE DESIGN DIRECTOR Tom Bentkowski
LIFE SPECIAL PROJECTS ART DIRECTOR Mimi Park

PRESIDENT Andrew Blau
BUSINESS MANAGER Roger Adler
BUSINESS DEVELOPMENT MANAGER Jeff Burak

TIME INC. HOME ENTERTAINMENT
PUBLISHER Richard Fraiman
GENERAL MANAGER Steven Sandonato
EXECUTIVE DIRECTOR, MARKETING SERVICES Carol Pittard
DIRECTOR, RETAIL & SPECIAL SALES Tom Mifsud
DIRECTOR, NEW PRODUCT DEVELOPMENT Peter Harper
ASSISTANT DIRECTOR, BOOKAZINE MARKETING Laura Adam
ASSISTANT PUBLISHING DIRECTOR, BRAND MARKETING Joy Butts
ASSOCIATE COUNSEL Helen Wan
BOOK PRODUCTION MANAGER Susan Chodakiewicz
DESIGN & PREPRESS MANAGER Anne-Michelle Gallero
BRAND MANAGER Shelley Rescober

Special thanks to Christine Austin, Glenn Buonocore,
Jim Childs, Rose Cirrincione, Jacqueline Fitzgerald,
Lauren Hall, Jennifer Jacobs, Suzanne Janso, Brynn Joyce,
Mona Li, Robert Marasco, Amy Migliaccio, Brooke Reger,
Dave Rozzelle, Ilene Schreider, Adriana Tierno,
Alex Voznesenskiy, Sydney Webber, Jonathan White

EDITORIAL OPERATIONS Richard K. Prue (Director),
Brian Fellows (Manager), Keith Aurelio, Charlotte Coco,
John Goodman, Kevin Hart, Norma Jones, Mert Kerimoglu,
Rosalie Khan, Patricia Koh, Marco Lau, Brian Mai,
Po Fung Ng, Lorenzo Pace, Rudi Papiri, Robert Pizaro,
Barry Pribula, Clara Renauro, Donald Schaedtler, Hia Tan,
Vaune Trachtman, David Weiner

Copyright © 2009 Time Inc. Home Entertainment

Published by LIFE BOOKS

Time Inc.
1271 Avenue of the Americas
New York, New York 10020

ISBN 13: 978-1-60320-078-3
ISBN 10: 1-60320-078-9
Library of Congress Control Number: 2009902314
"LIFE" is a trademark of Time Inc.

We welcome your comments and suggestions about LIFE Books.
Please write to us at:
LIFE Books
Attention: Book Editors
PO Box 11016
Des Moines, IA 50336-1016

If you would like to order any of our hardcover Collector's
Edition books, please call us at 1-800-327-6388.
(Monday through Friday, 7:00 a.m.— 8:00 p.m. or
Saturday, 7:00 a.m.— 6:00 p.m. Central Time).

THE FOLLOWING ARE REPRINTED BY PERMISSION
OF THE COPYRIGHT HOLDERS:

"Inquiring Camera Girl" column—reprinted by permission of
The Washington Post;

"Senator and Mrs. Kennedy, Georgetown, 1954," four
photographs by Orlando Suero/Lowenherz Collection/Peabody
Institute of the Johns Hopkins University, Baltimore;

"The funeral procession of President John F. Kennedy,"
photograph © Henri Dauman, 1963, N.Y.C.;

"Memory of Cape Cod," by Edna St. Vincent Millay, © 1923,
1951, by Edna St. Vincent Millay and Norma Millay Ellis.
From *Collected Poems of Edna St. Vincent Millay,* HarperCollins.
Reprinted by permission of Elizabeth Barnett, literary executor.

Endpapers: Jackie and Caroline in Middlebury, Virginia, in 1961.
Photograph by Jim Mahan.

More Pictures of Jackie at LIFE.com
Our interactive Web site that launched this spring—simply put, the most amazing
collection of professional photography on the Internet, with millions of iconic
images from LIFE magazine's archives—now features a special gallery devoted
to Jacqueline Kennedy Onassis to coincide with the publication of this book
and with the anniversary of her death. Please go to *life.com/books/jackie.*

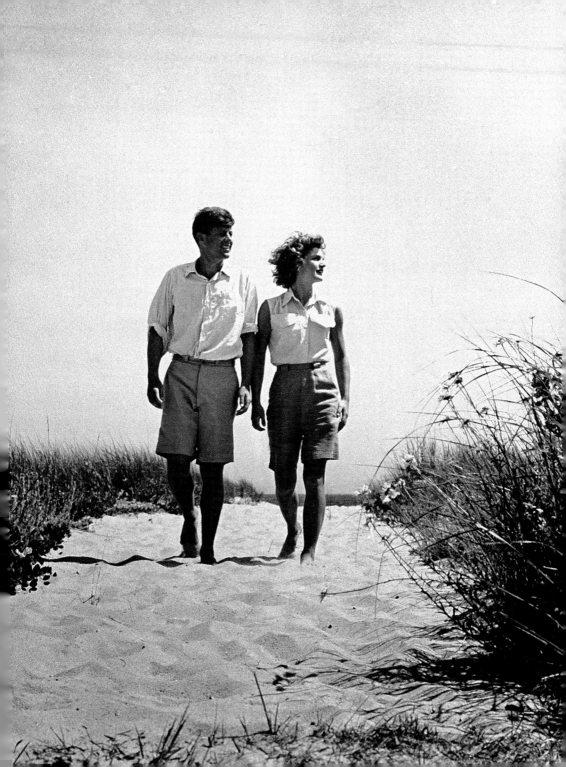

When we first published this volume commemorating one of America's best-loved women 15 years ago, the late Hugh Sidey, LIFE's noted former White House correspondent, began his foreword thusly: "The life of Jacqueline Kennedy Onassis was her art, a finely wrought miniature that history enlarged and then tempered by tragedy and finally veiled in privacy. As a Bouvier she inherited a tradition of elegance that became her way of life and her fortress in misfortune. She had

a gift of grace, an innate sense of right proportion that shaped her values and her choices. Everything she did was done with style—a style that was shaped by her mind and her heart. She was civilized and civilizing; whatever she touched, she refined."

Sidey's poetic appraisal reminds us today of the unique je ne sais quoi of Jackie, and prompts the reflection that there has been no one quite like her since she left us. She was glamorous in a way Hollywood actresses couldn't match. She was at once enigmatic, beguiling, entrancing. She was smart and quick-witted. She had not only the innate stylishness Sidey wrote of but a great deal of class. It has been observed many times that Jack and Jackie were a kind of American royalty, and there is something to that. In the early 1960s, the country was in thrall to this dynamic young couple—and, of course, to their charming children. The Kennedys made us smile with pride. They elevated us.

Jackie was not always comfortable in the glare shone upon the family by the White House press corps and was particularly protective of her kids. She took her role as mother very seriously—"If you bungle raising your children," she once said, "I don't think whatever else you

do well matters very much"—and was concerned that Caroline and John Jr. lead as normal lives as possible. But when Jackie's back was turned or she was out of town, Jack would sneak photographers into the West Wing, and frames of the little ones gamboling in the Oval Office would wind up in the next week's edition of LIFE. JFK knew that America loved the kids and that these pictures were good for presidential popularity, but if Jackie had had her way, there would have been a solid wall built between her children and the prying press.

It is fortunate for us now, of course, that the pictures exist to brighten a book such as this celebration of Jackie. But it is good to know before we proceed that our subject was an often private, serious-minded woman who did not court the celebrity that befell her, and with which she was often uncomfortable.

With the attractive young Obama family now ensconced in the White House, there have been many references made to a second coming of the Kennedys. Certainly there are similarities—the big smiles, the effortless style, the cute kids—but it can never be the same. The fantastically charismatic and photogenic Kennedys were

a First Family unlike any we had ever seen, and you can only experience that initial romance once.

When Jackie took on the restoration of the White House as her first major project, then led the American public on a televised tour of the results, her already substantial popularity soared. She inspired the citizenry, particularly women. Her hair-do became a national emblem of sorts and was emulated everywhere; she caused a run on pill-box hats, and was responsible for selling more than a few A-line dresses. As she was a quieter and more dignified celebrity than movie or rock-and-roll stars, it is not quite right to equate the stir caused by Jackie to, say, Beatlemania. Yet, as the pictures in this book will remind us, excitement followed in Jackie's wake.

As Sidey wrote in 1994: "Jackie, surely as much as Jack, helped make the magic we called Camelot. But when an assassin's bullets shattered the dream, she showed the world that there was unimagined strength beneath the silk. Her courage, her dignity, her grave restraint in the face of such horror held this nation together and showed us how to grieve.

"In the years after Jack's death, Jackie struggled to rebuild her life. The public sentenced her to a widowhood of black lace and prayer. She declined the role. In 1968, five years after the assassination, she married Greek billionaire Aristotle Onassis, shipping buccaneer and man of the world. For the next six and a half years, until his death, she endured a regime of tabloid assault. As always, she kept her priorities straight. She raised her children wisely and carried on a quiet campaign to support the arts and humanities. She became a book editor and produced many volumes of true distinction. As the years went by, Jackie faded from public view. But when she died, we realized how much we missed her. And we remembered how much we loved her."

All true, and it is sad to note 15 years on that we have been reminded yet again in the interim just how much we loved them all, those glittering Kennedys. As we know, Jackie's seriousness of purpose concerning motherhood paid off, and Caroline and John Jr. grew to be sparkling young adults. Caroline married and raised a family in New York City, meanwhile following her mother's lead in staying active behind the scenes with selected philanthropies. Her younger brother eventually followed their mother's example in another realm—publishing—as he became founding editor of a politics and lifestyle magazine, George. He, too, married, and the future seemed full of possibility for him when, in 1999, the small plane he was piloting to Martha's Vineyard went down in the Atlantic, and John Jr., his wife and sister-in-law were killed.

In the midst of this tragedy, the memory of the gaiety, the optimism, the hope that had once attended the Kennedys all came rushing back again, just as it had when Jackie died. The images came flooding back to our consciousness: the dashing war-hero senator from Massachusetts courting and winning the beautiful socialite; the thrill of the inauguration; the children in the executive mansion and then, later, as adults, making their mother proud . . .

In these pages, we can go back in time. Not to a simpler era, necessarily, but to a sunnier one for this famous family. You look at these pictures, and you hear the music playing.

> Ask ev'ry person if he's heard the story,
> And tell it strong and clear if he has not,
> That once there was a fleeting wisp of glory
> Called Camelot . . .
>
> Don't let it be forgot
> That once there was a spot
> For one brief shining moment that was known
> As Camelot.

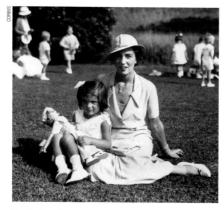

Janet Bouvier, with three-year-old Jackie at the 14-acre Bouvier estate in posh East Hampton, on Long Island. She was an erratic and temperamental mother.

❝ *Sunday, July 28, 1929, was a scorcher along the eastern seaboard of the United States, and the following day* The New York Times *reported 'record throngs at local beaches.' In Southampton, toward the tip of Long Island, a gathering of prominent residents attended a series of luncheons and parties to raise money for a hospital. Their names were listed in the* Times *on Monday, and it is possible that those of Jack and Janet Bouvier, who had been married a year earlier in the social event of the season, might have been among them but for the fact that Janet was at a nearby private hospital giving birth to an eight-pound daughter. Her parents decided to name her Jacqueline.* **❞**

FROM LIFE'S CELEBRATION OF HER SIXTIETH BIRTHDAY, JULY 1989

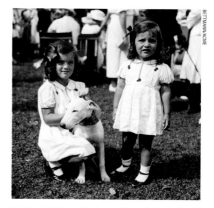

Jackie (left), with her sister, Lee, brought Regent to the 1935 dog show in East Hampton. When they were young, Lee was noted for her beauty, Jackie for her brains.

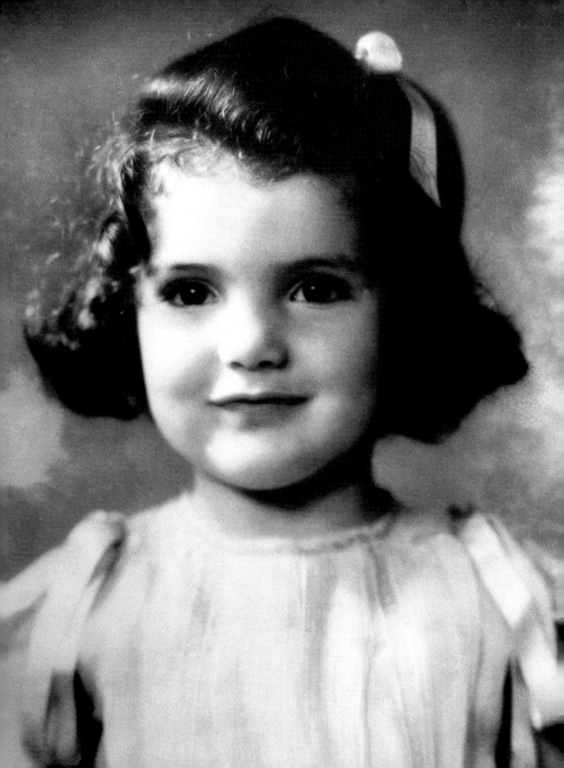

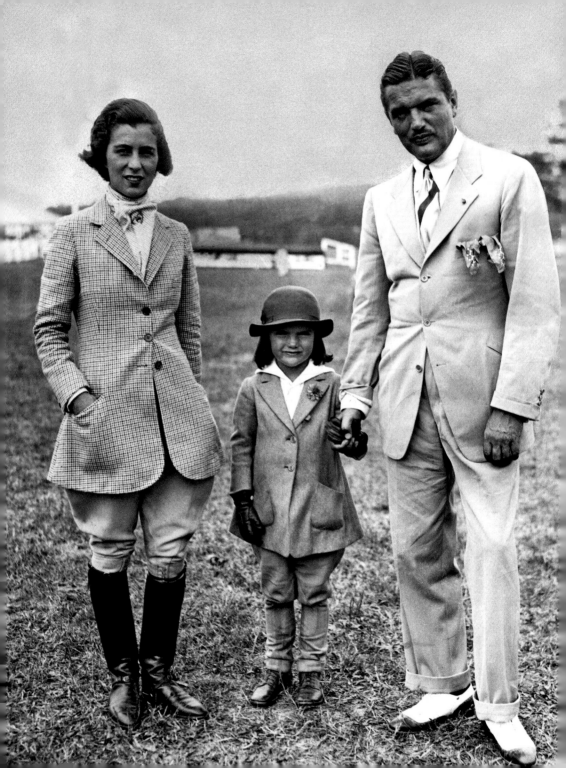

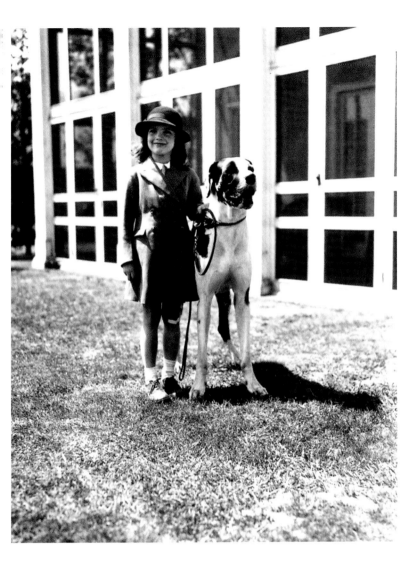

The family menagerie included three pedigreed dogs, six thoroughbred horses and, for a time, a rabbit that Jackie kept in the bathtub. She starred at horse shows beginning at five, and at seven was back at yet another dog show to exhibit her Great Dane, King Phar (left). In many ways, she was able to forge firmer bonds with her pets than with her parents: Black Jack's extravagances (both personal and financial) kept the couple distracted from their children.

"A bright, alert, but high-strung child, a little difficult to manage"

—BERTHE KIMMERLE, JACKIE'S GOVERNESS

The Bouviers were an ill-matched pair. "Black Jack" came from money, but he had a hard time keeping it; Janet Lee rose from more modest roots but craved the good life. In 1934, after Bouvier had suffered enormous losses on Wall Street, the couple took five-year-old Jackie to the Southampton Riding and Hunt Club for the annual horse show. Jackie was 11 when her mother and father finally divorced. The separation was, for her, a crushing blow.

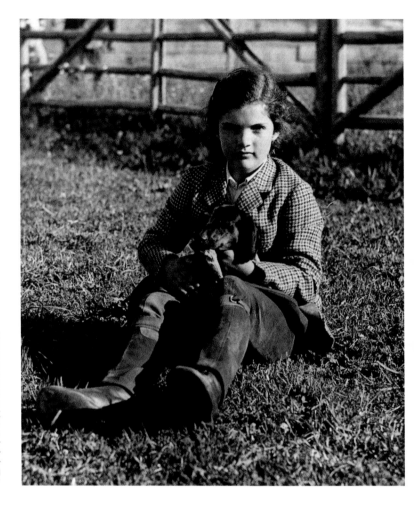

Jackie (here with her dog Tammy in 1938) often sought refuge from the rigorous social life of the Bouviers. While her gregarious younger sister enjoyed the limelight, Jackie preferred to spend hours alone in her room reading or listening to music. She sketched pictures, wrote poetry and played with her animals, prompting her mother to worry that her elder daughter might end up a "bluestocking."

"It wasn't a social thing with her. . . . She was a stayer, not a fair-weather foxhunter." —JAMES L. YOUNG, RIDING FRIEND

Jackie seemed to love all animals, but a family retainer described her as having "a passionate fondness for horses." On a day at the races at Belmont Park, the nine-year-old tomboy posed with scraped knees, flyaway hair and preternatural poise. Six years later, when her mother and new stepfather, Hugh Auchincloss, packed her off to Miss Porter's School in Farmington, Conn., Jackie took her horse Danseuse with her.

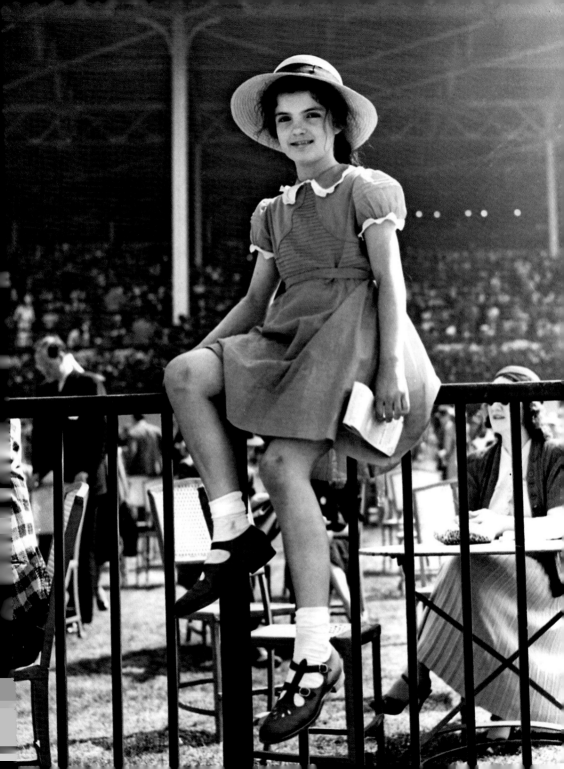

PETER BRENNAN

The shy girl who had entered Miss Porter's finishing school at 14 emerged three years later with a notable confidence. In 1946 she struck a sultry, if clowning, pose with two of her classmates.

❝*The handsomest young member of the U.S. Senate was acting last week like any young man in love. To the family home on Cape Cod, John F. Kennedy brought his fiancée for a weekend of fun.*

Strictly speaking—according to Webster at least—the courtship of former Ambassador Joseph P. Kennedy's son and Jacqueline Bouvier terminated with the announcement of their engagement. But the courtship between the 36-year-old Massachusetts senator and his 23-year-old fiancée goes on. Jackie, an inquiring photographer for a Washington newspaper, occasionally ran into Kennedy, whom she had met before socially, on her question-asking excursions to Capitol Hill. Now she admits she is less inquisitive—'We hardly ever talk politics.'❞

FROM "LIFE GOES COURTING WITH A U.S. SENATOR," JULY 20, 1953

At her Newport, R.I., coming-out party, Jackie appeared in a $59 off-the-rack gown. Still, she so impressed a New York society columnist that he pronounced her Debutante of the Year.

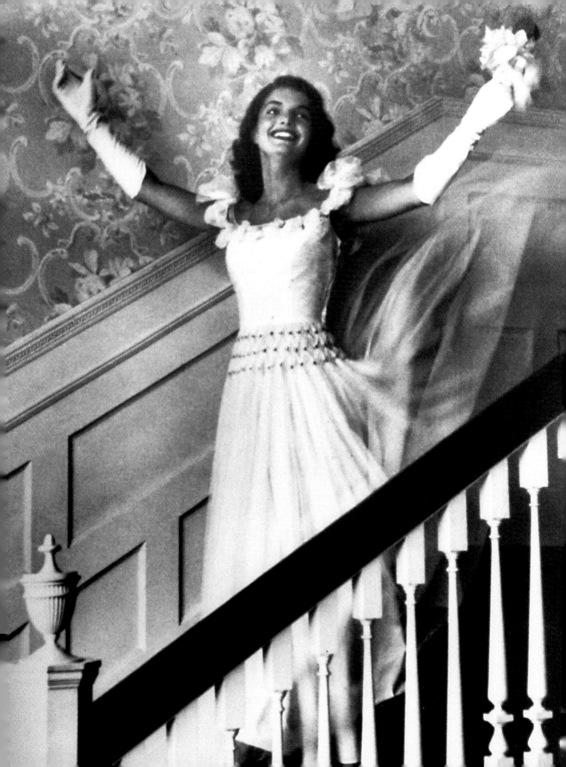

In 1951, Jackie won a *Vogue* magazine Prix de Paris essay contest; one of her winning entries was a tribute to Charles Baudelaire, Oscar Wilde and Sergey Diaghilev. "If I could be sort of overall Art Director of the 20th century, watching everything from a chair hanging in space, it is their theories of art that I would apply to my period, their poems that I would have music and paintings and ballets composed to." That same summer, the budding aesthete traveled to Europe with her sister. When they returned, they assembled an elaborate scrapbook and diary entitled One Special Summer, which they presented to their mother as a gift. The book, published in 1974, began with Jackie's own cartoon drawings of their passports and the legend: "At 9:45 p.m., June 7, 1951, after pleading and pestering and praying for a year—No. 218793 and No. 545527 left the country."

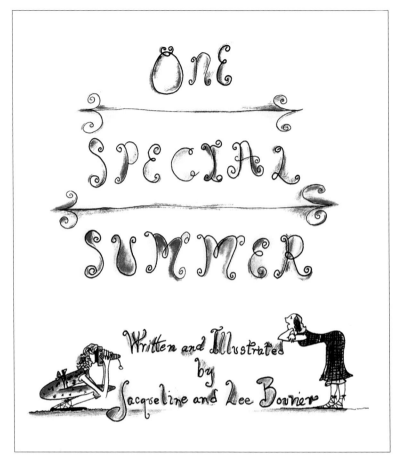

"I couldn't imagine anything that could be more fun than a trip with Jackie, since we both . . . had the same sense of the ridiculous."

—LEE BOUVIER RADZIWELL

Early on, Black Jack impressed the importance of fashion upon his two daughters. Jackie and Lee (here, in 1949) wore the same dress size, and occasionally the same clothes. The divorce of their parents had stilled their competition. "Nothing could ever come between us," Jackie said of her sister.

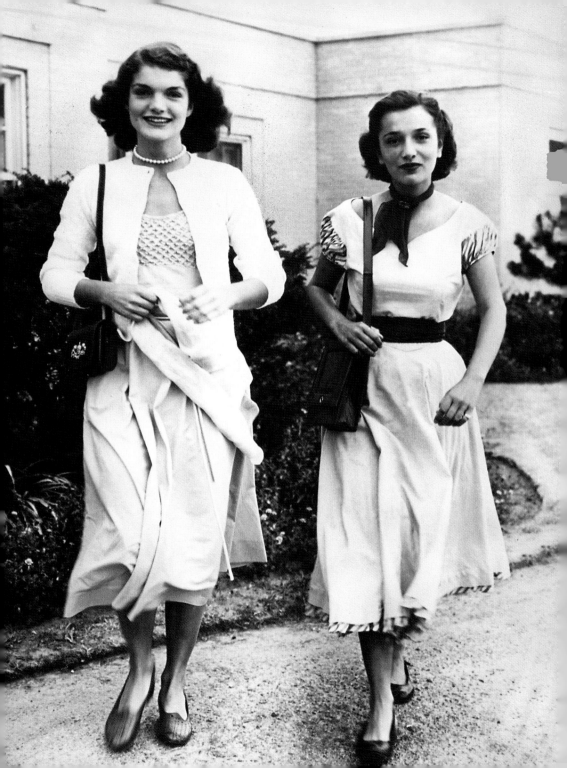

After reluctantly turning down an offer from *Vogue* to join the magazine's Paris office (her mother felt that she needed to spend more time stateside), Jackie took a $42.50-a-week job as an inquiring photographer for the *Washington Times-Herald*, asking strangers such questions as "Are men braver than women in the dental chair?" and "Noel Coward said, 'Some women should be struck regularly, like gongs.' Do you agree?"

For one column (right), Jackie asked the Capitol pages to comment on the senators they served. Young Jerry Hoobler told her, "Senator Kennedy always brings his lunch in a brown paper bag." He then added that Kennedy's youth sometimes got him into trouble. "The other day he wanted to use the special phones, and they told him, 'Sorry, mister, but these are reserved for senators.'"

Inquiring Camera Girl
By JACQUELINE BOUVIER

THE QUESTION

What's it like observing the pages at close range? Asked of senators and the Vice President.

THE ANSWERS

Vice President Richard M. Nixon: I would predict that some future statesman will come from the ranks of the page corps. During my time as a senator, I noticed that they are very quick boys, most of whom have a definite interest in politics. I feel they could not get a better political grounding than by witnessing the Senate in session day after day as they do.

Sen. John F. Kennedy (D) of Massachusetts: I've often thought that the country might be better off if we Senators and the pages traded jobs. If such legislation is ever enacted I'll be glad to hand over the reins to Jerry Hoobler. In the meantime, I think he might be just the fellow to help me straighten out my relationship with the Tops. I've often mistaken Jerry for a senator because he looks so old.

Sen. Wallace F. Bennett (R) of Utah: We senators like to help out the pages, and we like to kid them a little too. You know Sen. Morse has hit upon the device of having the journal read at the start of every session. Recently a senator who shall be nameless told a new page that from now on the journals for the week would be read on Saturday, with only the pages present. The poor little fellow believed him.

Sen. Robert A. Taft (R) of Ohio: I think I do remember a fairly good-sized boy running in to me once. That sort of thing doesn't often happen, tho. He was just a new boy, and in his eagerness, he was exceeding the speed limit. They are good boys. They're all very willing and they've got a good school for them up here.

Sen. Pat McCarran (D) of Nev.: My advice to a new senator is to cultivate the friendship of the pages. They form likes or dislikes as fast as the weather changes in Washington. They'll run errands for you as slow or as fast as they're interested by your personality or pleased by your kindness to them. They watch the senators much more closely than we realize we're being watched.

Sen. Clyde R. Hoey (D) of N. C.: I have a very good time with the pages. I like to talk to them. We discuss the previous pages who served here, then went on to become senators; like Sen. Wallace White, the Republican minority leader from Maine, and Arthur Pew Gorman from Maryland. They're all rather intrigued with the idea of becoming senators.

THE QUESTION

What's it like observing the senators at close range? Asked of Senate pages.

THE ANSWERS

Gary Hegelson, Wisconsin: We've got this book with pictures of senators in it and I'm trying to get their autographs. I didn't know when I could get Nixon, he's so busy. One day when he was presiding over the Senate and I was sitting on the rostrum I decided that was my chance. He signed it right away.

Jerry Hoobler: Senator Kennedy always brings his lunch in a brown paper bag. I guess he eats it in his office. I see him with it every morning when I'm on the elevator. He's always being mistaken for a tourist by the cops because he looks so young. The other day be wanted to use the special phones, and they told him, Sorry, mister, but these are reserved for senators."

Johnny Bracken, Conn.: Sen. Bennett is the only senator to serve as a page. Once one of the telephone boys yelled over his shoulder "Go get Sen. Goldwater. He's got a call." He never looked to see who he was yelling at. The next thing we knew, Sen. Bennett was sighted running all over the floor and thru the lobbies.

Jim Feeney, N. D.: I nearly knocked Sen. Taft down my second day as a page. I was running across the floor with a message for another senator and I missed him by an inch. But just laughed and said, "Better watch where you're going." Another time I felt silly was when I had to pick up two ducks in Sen. Langer's office and take them to the kitchen to be cleaned.

Peter Grose, Ariz.: We saved Sen. Douglas from catastrophe. When he's talking, he always has water on his desk. He'll pause and drink the whole glass at one gulp. We give him mineral water, but one of the new boys grabbed soda water from the icebox by mistake.

Jim Reynolds, Wisc.: The senators are always real friendly, but the other pages think up jokes to play on you when you're new and don't know the ropes. They tell you to go and get tomorrow's Congressional Record. I didn't fall for that one, but when they sent me to find a bill stretcher for Sen. Snorgum, I ran around for two hours before I realized there was no such senator or no such thing.

Dinwoody Again Heads National Affairs, Inc

Stockholders of the Bureau of National Affairs, Inc., have re-elected Dean Dinwoody of Chevy Chase, Md., as president. Lowell

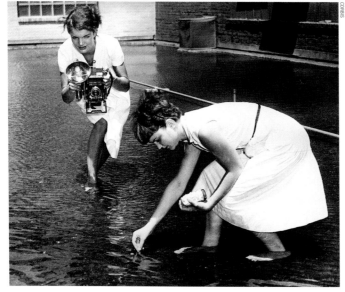

The girl who once told a friend "I'm sure no one will ever marry me" had been a popular date in Washington. But at a dinner given by newspaperman Charles Bartlett, Jackie sat across from Kennedy. Although their courtship was spasmodic, he pursued her with characteristic energy. "I think he understood that the two of them were alike," JFK friend Lem Billings later said. "They had both taken circumstances that weren't the best in the world when they were younger and learned to make themselves up as they went along." Shortly after they became engaged, Jack invited her to the Kennedy home in Hyannis Port (opposite).

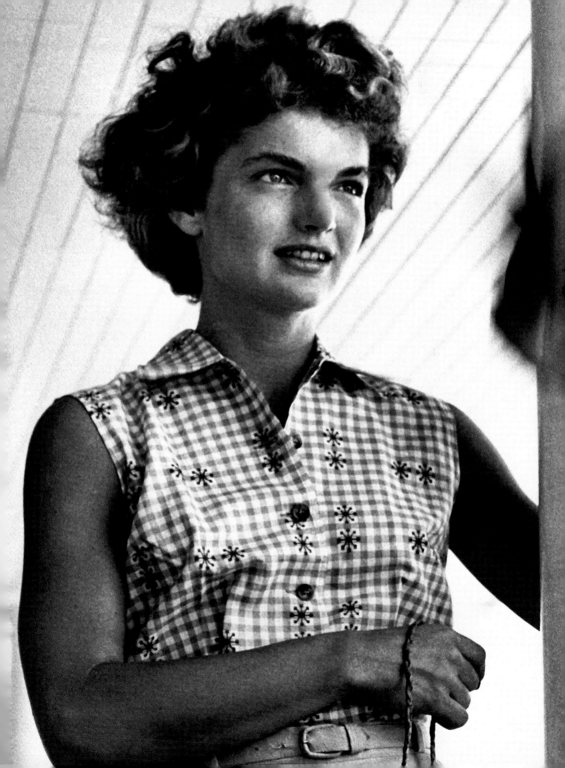

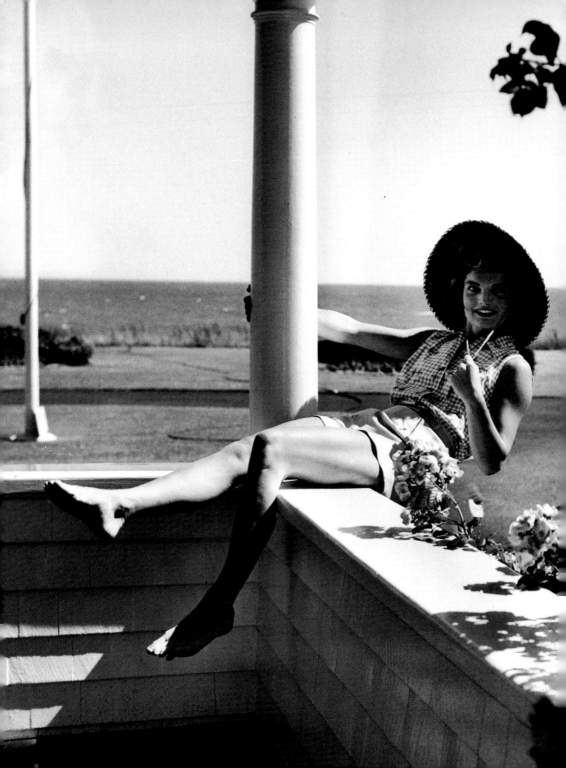

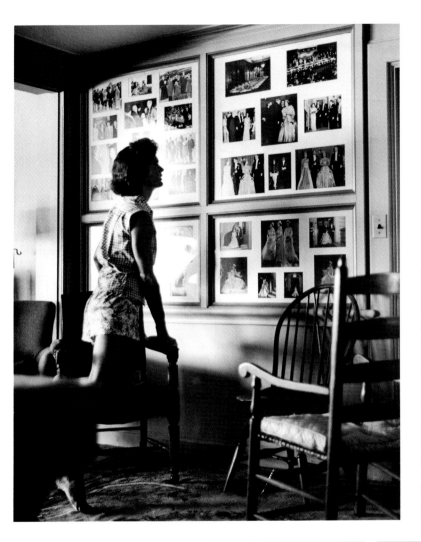

At Hyannis Port, Jackie, whose own family had been listed in the first edition of the Social Register in 1889, sized up her future in-laws' family photos, including shots of the Kennedys with England's royal family taken during Joe's years as ambassador.

Jackie gamely entered the Kennedy family's sporting fray, but in later summers, after breaking her ankle in touch football, she would generally encamp on the porch. There she passed her time chatting about movies and classical music with her father-in-law as the games continued on the lawn below.

For a romantic like Jackie (left), the rough-and-tumble of the Kennedy family was a foreign culture. Although teased by the Kennedy sisters as "the Debutante" with the "Babykins" voice, the strong-willed Jackie held her ground, and the Kennedy family accepted her. "I think Jack is a topside fellow, but he certainly is very fortunate to get as lovely a girl as his bride," Joseph Kennedy said.

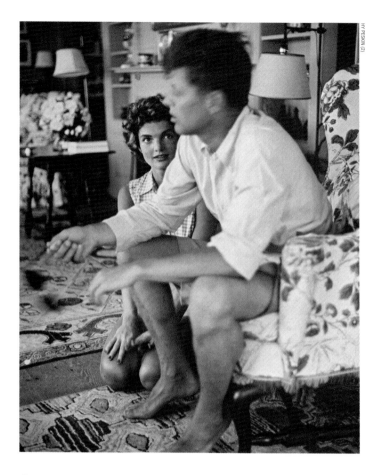

As her future husband talked politics at Hyannis Port, Jackie looked worshipful. To those who dismissed Jack as an ambitious glamour boy, she defended him fiercely. "He has this curious, inquiring mind that is always at work," she said. "If I were drawing him, I would draw a tiny body and an enormous head."

"They were kindred souls, two halves of the same whole."

—KENNEDY FRIEND LEM BILLINGS

Two months before the wedding, the engaged couple sailed off Cape Cod. Despite their matching smiles, the courtship had hardly been fairy-tale stuff. At the bridal dinner, she would joke that Jack's epistolary efforts had consisted of one item: a postcard from Bermuda, containing only the words "Wish you were here. Jack."

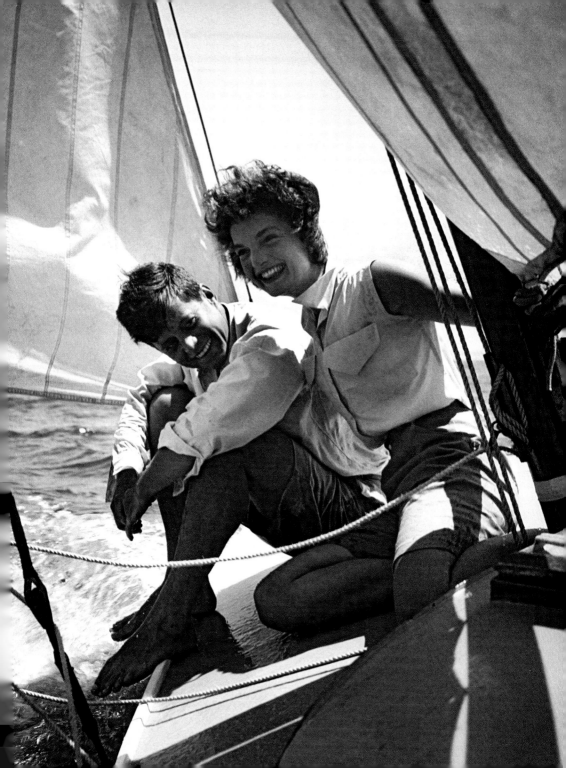

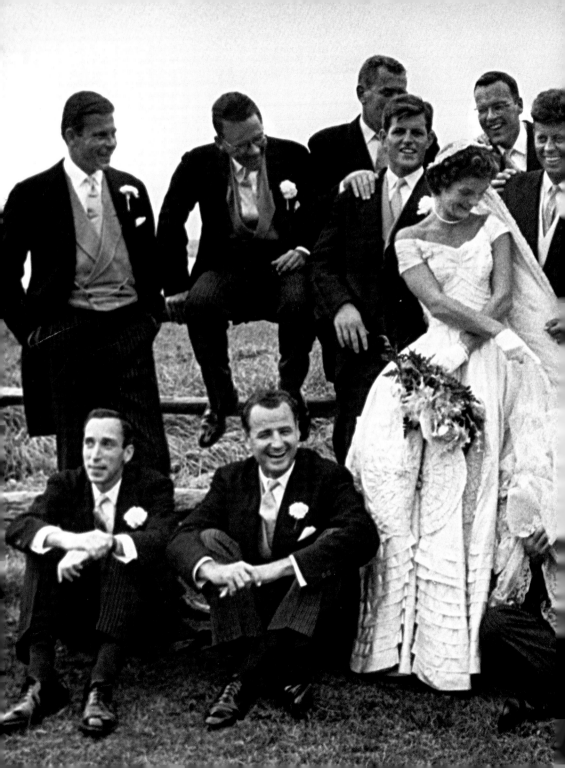

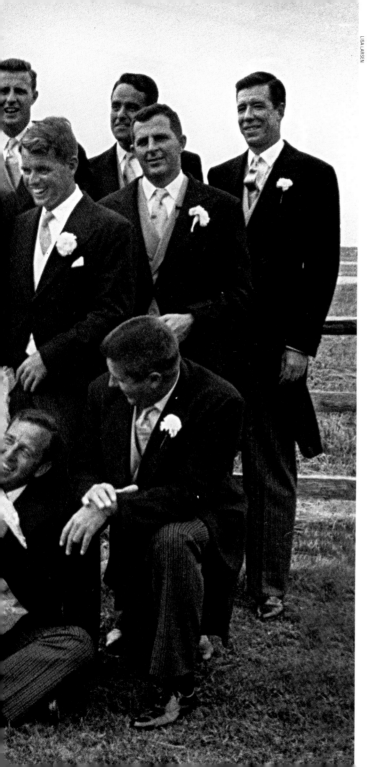

September 12, 1953, was sunny, warm and windy enough to ruffle the Kennedy hair. The bridal party included 14 ushers (Teddy is behind Jackie's right shoulder, and Bobby is next to Jack), 10 bridal attendants (not pictured) and one exhilarated couple.

After a wedding ceremony that, according to one newspaper, "far surpassed the Astor-French wedding of 1934 in public interest," the mother of the groom touched up her face—while the bride peered out the window as guests arrived for the reception.

The party was held at Hammersmith Farm, the Auchincloss summer house in Newport, R.I. Jack had intended to limit invitations to "close friends," but, fueled by his father, the list grew to 1,200. It was mix of Newport socialites, Washington dignitaries and Boston-Irish pols. The receiving line took two hours to exhaust itself.

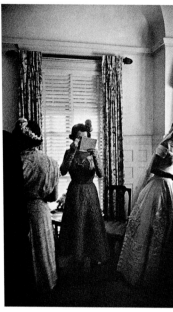

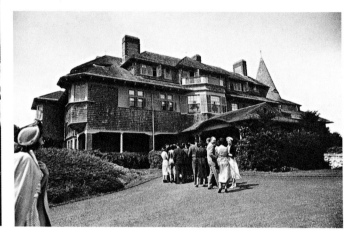

"A crowd of 3,000 persons broke through police

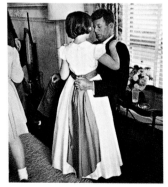

The groom dropped to his knees to share a moment with flower girl Janet Auchincloss, Jackie's half sister.

The bride, whose gown required 50 yards of ivory taffeta, wore her grandmother's wedding veil of rose-point lace and carried a bouquet of orchids and gardenias.

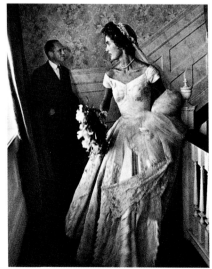

28

Kennedy siblings (from left) Pat, Bobby, Eunice, Teddy and Jean serenaded the newlyweds. The cake had been trucked down from a Quincy, Mass., bakery by a Kennedy constituent.

For the first dance, Jack chose "I Married an Angel" and waltzed with his bride until his father cut in. For Joe Kennedy, who orchestrated the wedding, the day was a social—and political—triumph.

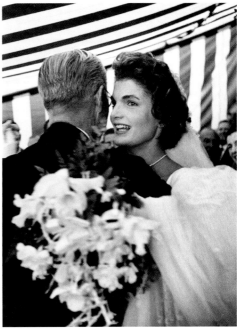

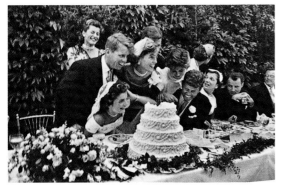

nes and nearly crushed the bride."—The New York Times

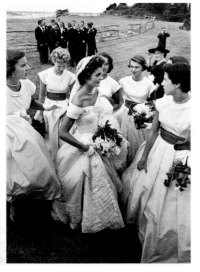

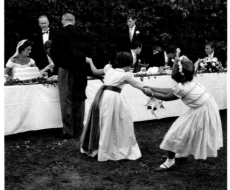

While Jackie chatted with her new father-in-law, her own father, Jack Bouvier, was nowhere to be found; he had gotten drunk in his hotel room and missed the ceremony.

Following pages: The couple sat down to a bridal meal of fruit cup, creamed chicken and ice cream sculpted to resemble roses. The entire affair, said one guest, was "just like the coronation" of Queen Elizabeth that spring.

The bridesmaids wore pink taffeta with crimson sashes; sister Lee, herself married only five months earlier to Michael Canfield, was the matron of honor.

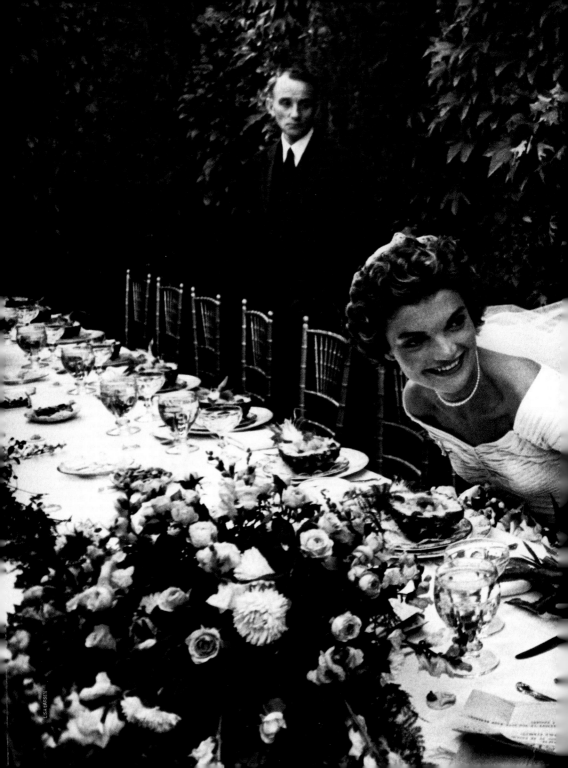

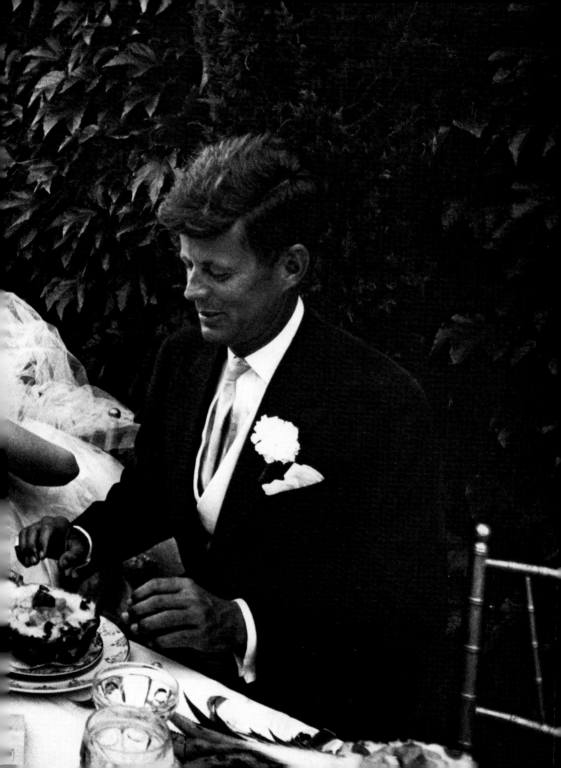

❝She is Jackie Kennedy, the cameo-faced wife of the presently front-running Democratic candidate, Senator John F. Kennedy. Until recently, Jackie was seldom on public display, a comparative stranger to the Washington round of dinners and receptions. She continues to prefer dinner for four on the patio of her Georgetown home to an embassy ball. She is happier in an art gallery than at a cocktail party.

Mrs. Kennedy, who dazzles the voters' eyes, is a sensitive, individualistic young woman. She is an amateur scholar of 18th-century European history ('I love and know the most about the 18th century'). She speaks Spanish, French and Italian fluently. Her interests run, as her husband puts it, 'to things of the spirit—art, literature and the like.' When, the senator lost the notes for a speech that he had planned to end with a quote from Tennyson's 'Ulysses,' Jackie bailed him out of trouble by quickly reciting the appropriate lines.❞

FROM "JOHN KENNEDY'S LOVELY LADY," BY DON WILSON, IN LIFE,
AUGUST 24, 1959

Following pages:
Although she loved the lively conversation of a good dinner party, Jackie entertained just twice during the first half-year of their marriage. One evening the guests included Janet Auchincloss. "I think I could entertain a king or queen with less apprehension than my mother," she said.

Among the newlyweds' first homes was a rented house in Georgetown where the senator spent a Sunday in May painting on the terrace. "I'm an old-fashioned wife," Jackie later told reporters. But her claim seemed at odds with at least one aspect of '50s wifeliness. "Jackie never did any manual labor," Kennedy's secretary, Evelyn Lincoln, said. "She didn't know how to clean a house."

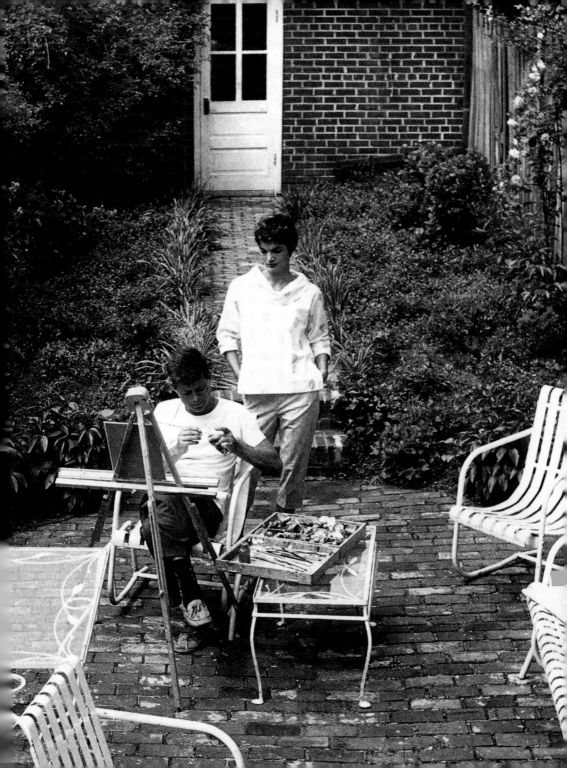

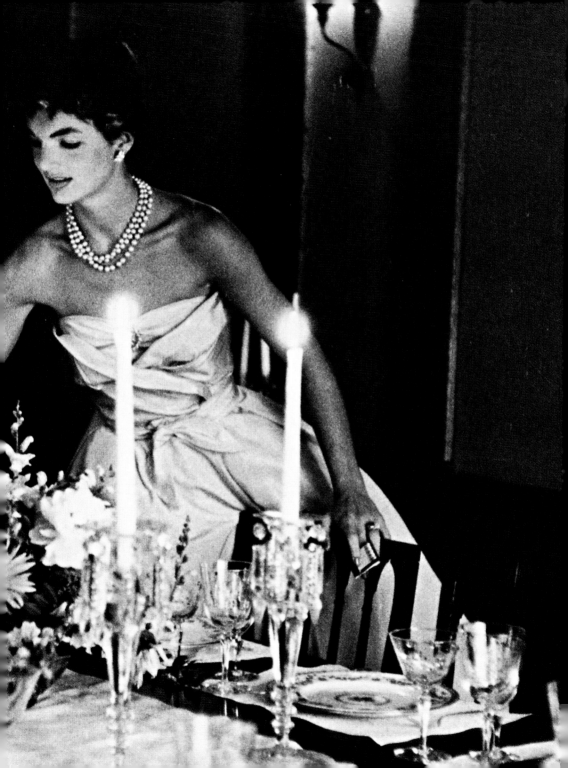

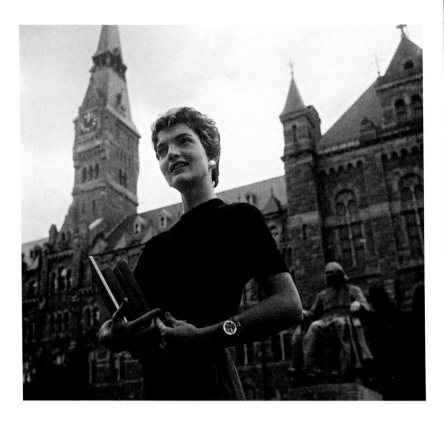

Jackie found her early life in Washington boring. Unusually young for a Senate wife, she tried to fit in by rolling bandages for the Red Cross with the other spouses. "They'd talk about their children and grandchildren," she complained, "and I would talk about my little half brother." The gritty world of politics seemed foreign too. She decided to learn more by taking a class in American history at Georgetown University. It didn't help. "The more I hear Jack talk about such intricate and vast problems, the more I feel like a complete moron," she said. "If he'd only change to European history, I'd have a chance."

Jackie was eager to get settled in Georgetown (right), so that she and Jack could get their many wedding presents out of storage. But it was tough to make their house feel like a home. Jack's political pals spent hours on end lounging with the senator. "They sprawled all over her furniture, broke her Sevres ashtrays, dropped their cigarette butts in her vases and, most of all, took up her husband's time," recalled Letitia Baldrige, later Jackie's social secretary. Jackie was outraged. "I told him I felt like we were running a boardinghouse, and he didn't understand."

When Jack's political obligations took him away (which they often did), Jackie sought solace in long horseback rides at Merrywood, her mother's estate in McLean, Va. (following pages). "I was alone almost every weekend," she said. "Politics was sort of my enemy, and we had no home life whatsoever."

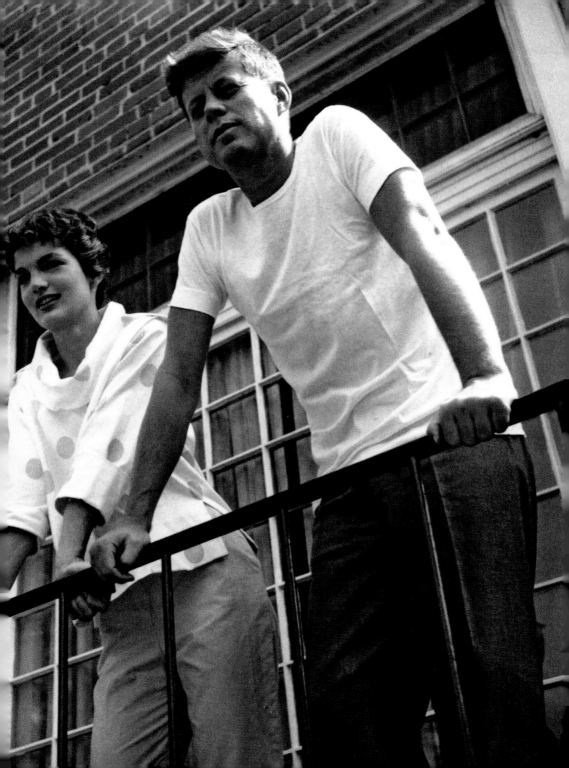

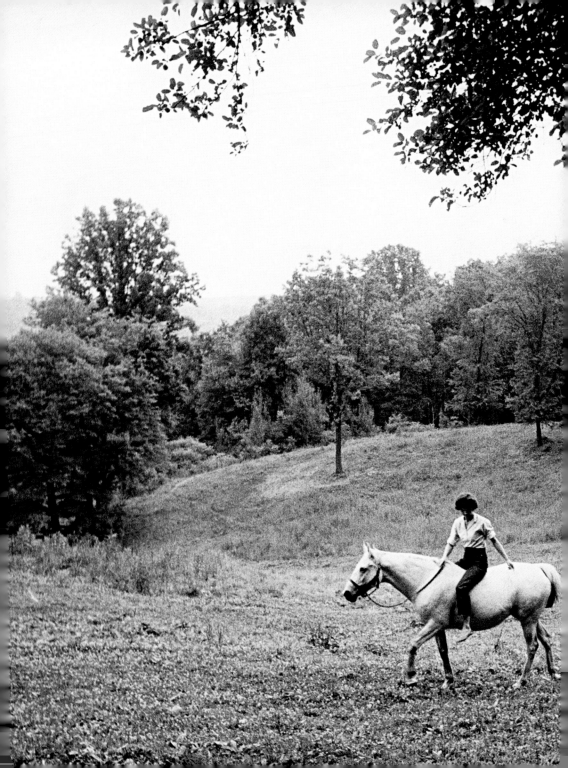

When she could, Jackie shunned the capital's gaudy embassy balls in favor of intimate dinner parties in her Georgetown home, including this soiree with Kentucky Senator John Sherman Copper and his wife.

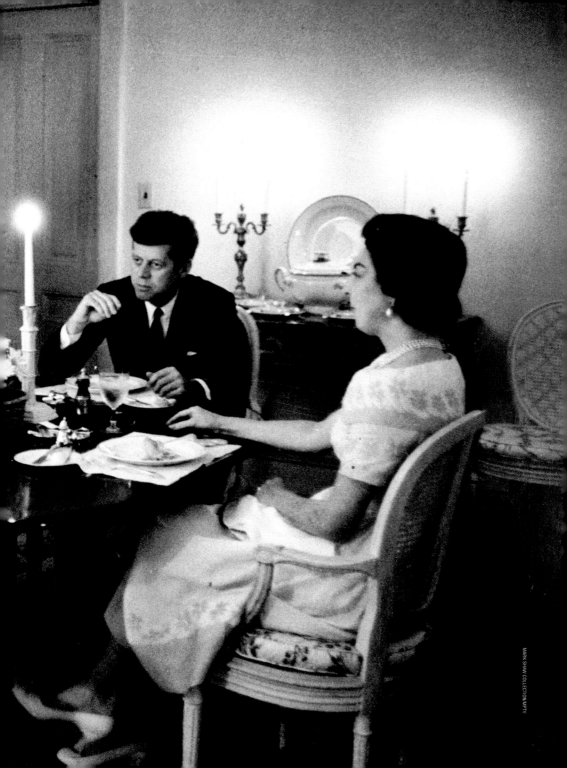

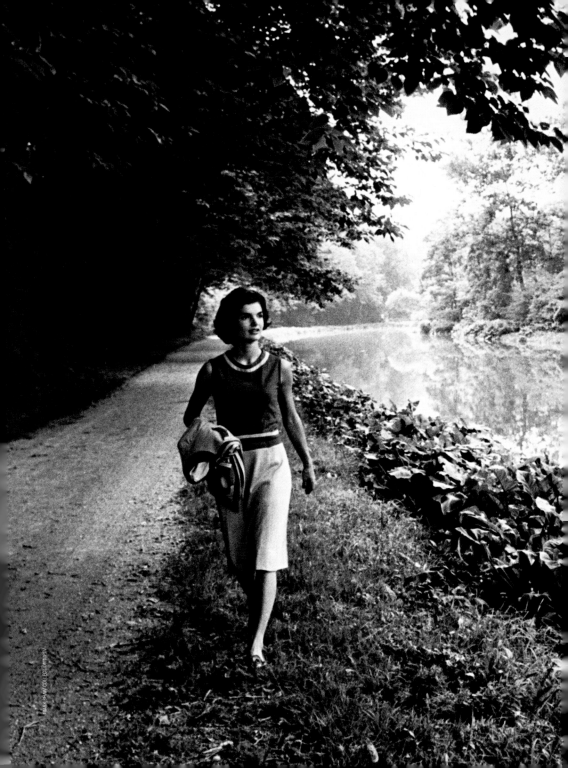

Although she privately abhorred "those crushing handshakes" and the "boring politicians" of the campaign trail, Jackie was a game, cheerful campaigner whose sophistication and allure made her a magnet for potential voters. "When Jackie was traveling with us, the size of the crowd at every stop was twice as big as it would have been if Jack was alone," said JFK aide Dave Powers. The Kennedys marched in a Columbus Day parade in East Boston in 1958, during his Senate reelection campaign.

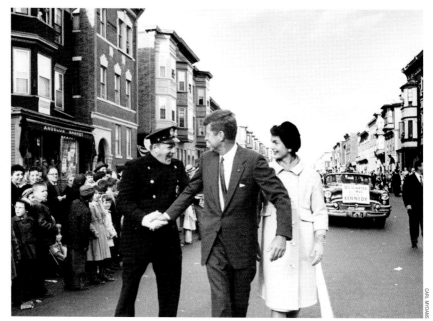

CARL MYDANS

"She breathes all the political gases that flow around us, but she neve.

By the fall of 1959, when the Kennedys pledged allegiance at a California high school, the senator had become an acknowledged, if unannounced, candidate for President.

Previous pages: "It was like being married to a whirlwind," said Jackie of her ambitious young husband. After the senator left for work, she often took a quiet stroll along the Chesapeake and Ohio Canal, which passed near their Georgetown home.

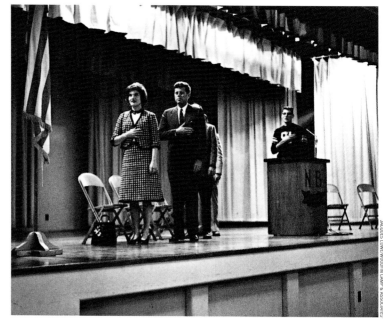

JACQUES LOWE, WOODFIN CAMP & ASSOCIATES

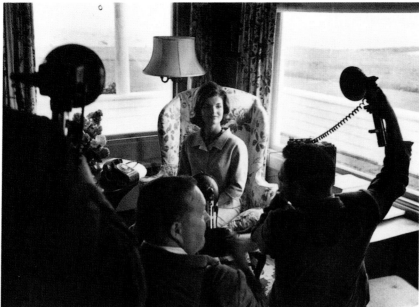

In January 1960, Kennedy made the formal announcement of his candidacy. A few months later Jackie learned she was pregnant, and her doctor ordered her to stay close to home. From there, she answered mail, taped TV spots, wrote a syndicated column ("Campaign Wife") and coped with the press. In July, on the day after Jack won his party's nomination in Los Angeles, Jackie was swamped by reporters in her Hyannis Port living room.

ems to inhale them." —JOHN F. KENNEDY

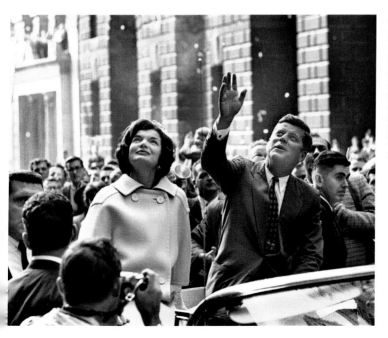

As the campaign against Richard Nixon came down to the wire, Jackie rejoined her husband on the road. "If he lost," she later said, "I'd never forgive myself for not being there to help." In the fall, they were in New York City, braving crowds so fervent a cop called the scene "worse than Omaha Beach."

Following pages:
When the Kennedys arrived in Portland, Oreg., for an early campaign appearance, they were met by only a few supporters, in an atmosphere of serenity they would rarely know again. Perhaps that was why a few years later JFK would call this his favorite photograph.

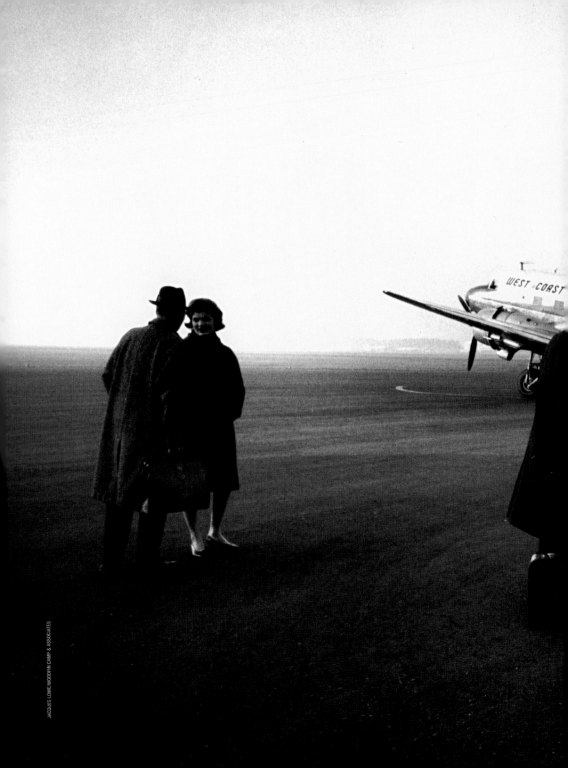

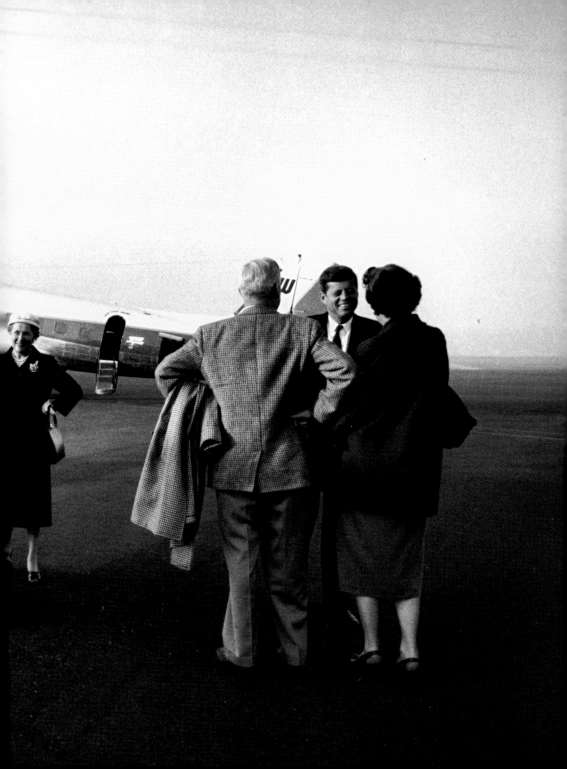

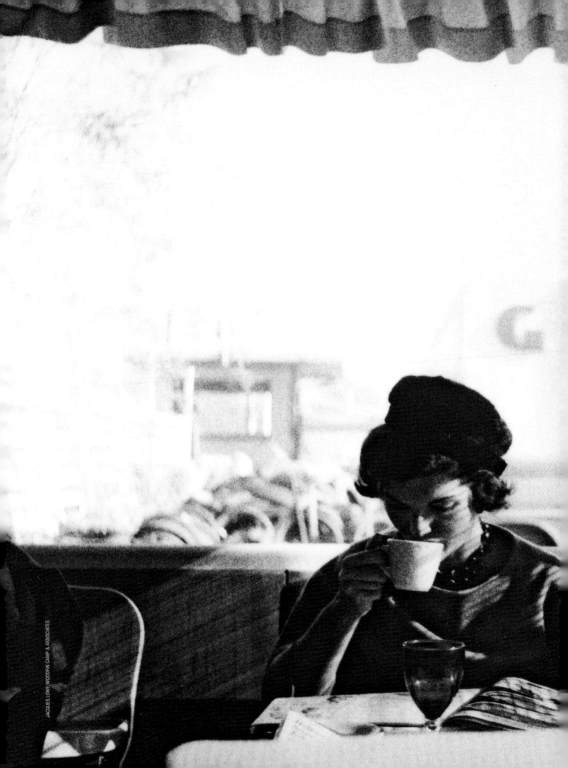

There were slow moments on the campaign trail. In a scene from 1959 worthy of Edward Hopper, the couple sat unnoticed by other diners as they joined Kennedy brother-in-law Stephen Smith for breakfast in a small Oregon town.

Mother: In the traditional style, John had politics, Jackie had family. But the two often mixed.

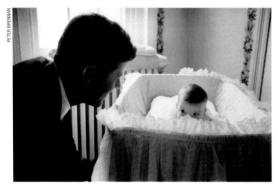

PETER BRENNAN

"No! She's sleeping," pleaded Jackie, but in 1958, Daddy awakened Caroline Bouvier Kennedy, one, anyway. "I'm not home much," he told his wife, "but when I am, she seems to like me."

❝Comparatively few of Jackie Kennedy's 31 years have been spent in public life. She is by nature a private sort of person and because she is pregnant now, she cannot travel with her husband in the campaign. This worries her: 'It's the most important time of Jack's whole life,' she says, 'and I should be with him.' But she welcomes the extra time with her daughter, Caroline, almost three. Her scrapbook contains few clippings; one is a convention story headlined 'It's Kennedy!' and another is titled 'Caroline's Turtles Place Second in Pet Show.'❞

FROM A LIFE ARTICLE ON MRS. KENNEDY AND MRS. NIXON, OCTOBER 10, 1960

By 1960, Caroline was two—and Jackie was pregnant again (right). The family had improved on their earlier homes with a larger and more elegant house in Georgetown **(following pages)**. But Jackie was beginning to wonder at what price. With the election coming, their lives were turning into public spectacle.

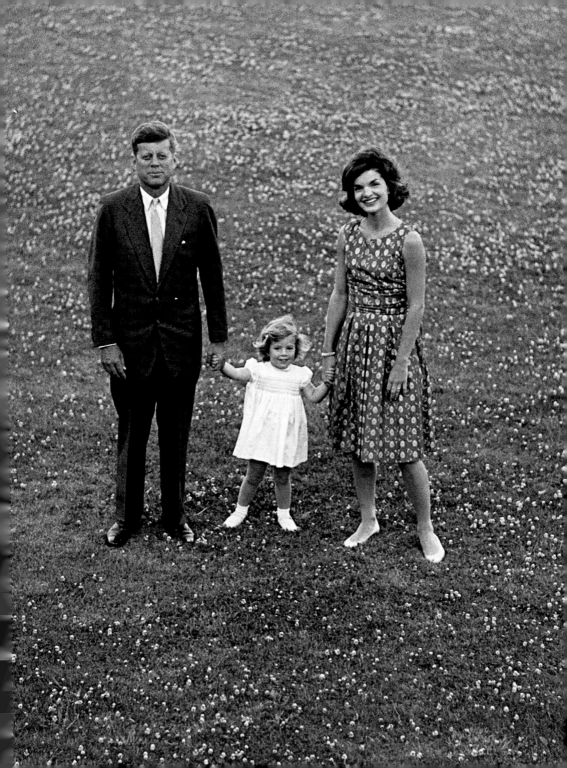

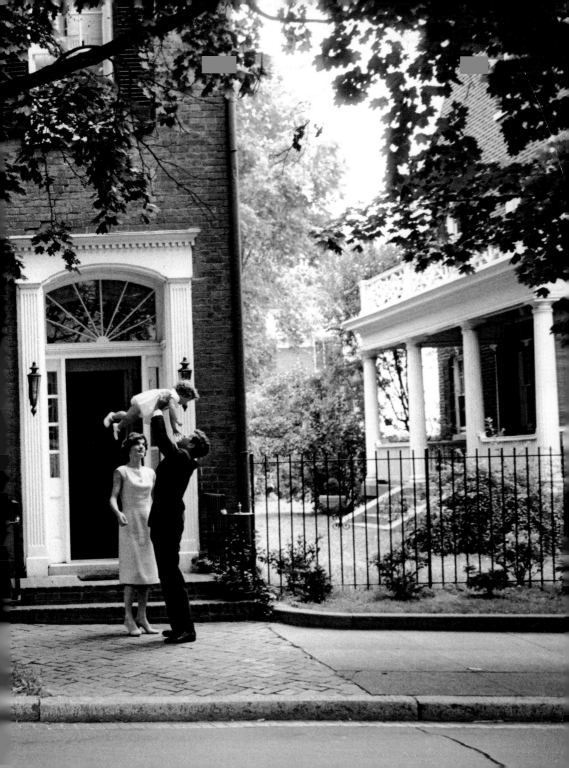

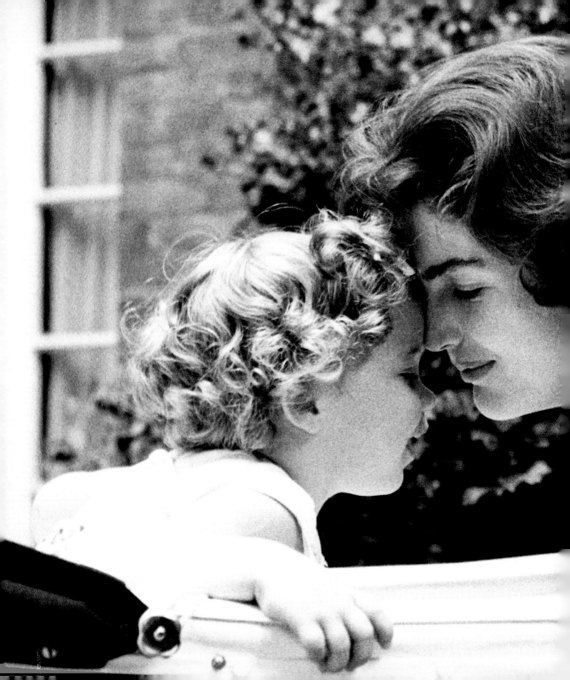

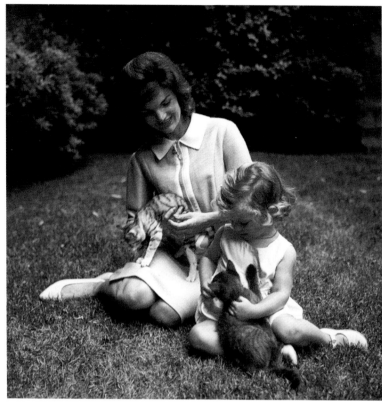

Family life fell into a pattern. Mother and daughter summered in the Kennedy compound in Hyannis Port (right) and wintered in Georgetown (**previous pages**). Daddy was usually on the campaign trail. Caroline's first spoken words were "goodbye," "New Hampshire," "Wisconsin" and "West Virginia." Said her mother: "I am sorry so few states have primaries, or we would have a daughter with the greatest vocabulary of any two-year-old in the country."

"Rearing children—I believe simply in love, security and discipline."

Following pages: During their stays in Hyannis Port, Jackie and Caroline often frolicked on Cape Cod's beaches. (The child at left is unidentified.)

"I mostly paint things for Caroline," said Jackie modestly. Her interest in art never faltered (friends like architect I.M. Pei were later to treasure her naive works), but her children always came first. To Jackie, the guiding precept of political motherhood was privacy, and as the election approached, she began to wonder how normal life would be possible in the White House. So well would she succeed in protecting her children that years later Hillary Rodham Clinton asked for the benefit of her experience.

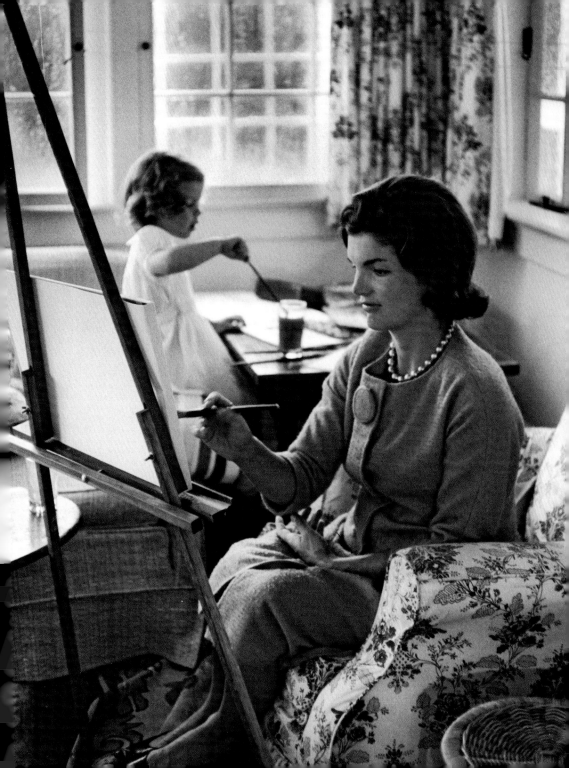

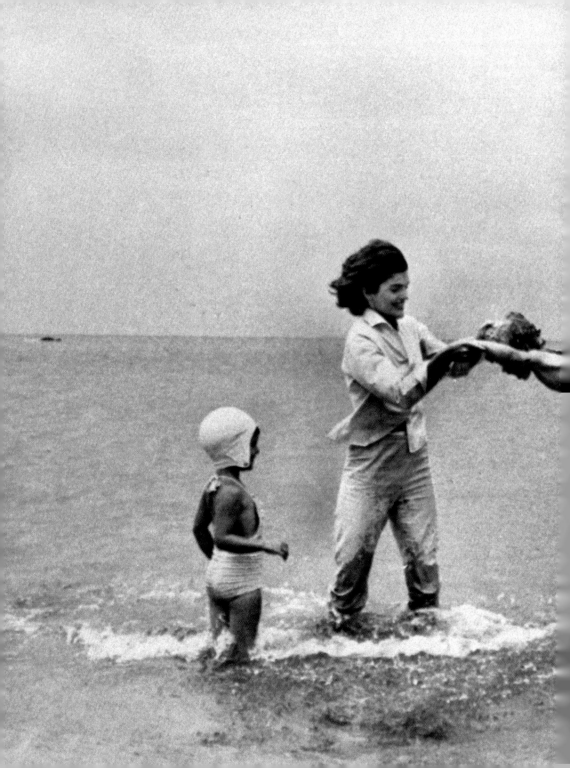

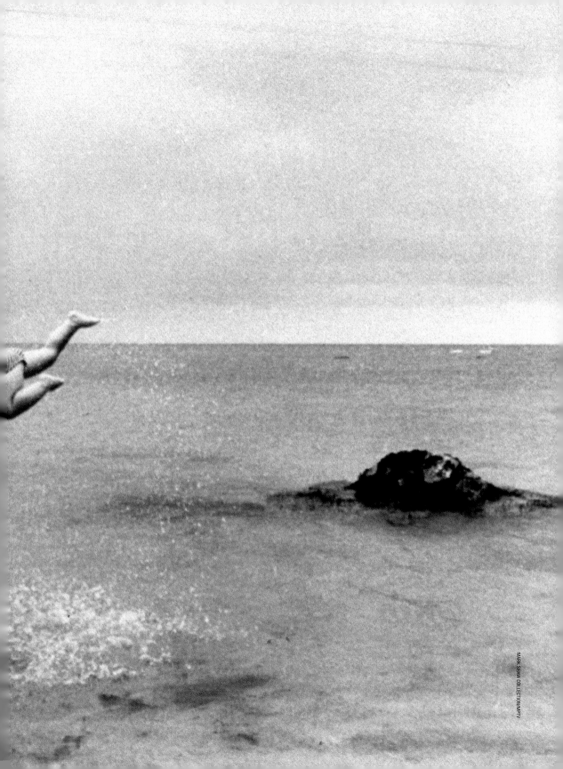

The gathering of the clan at Hyannis Port on the morning of November 4, 1960, was jubilant. From left: Ethel Kennedy, Stephen Smith, Eunice Shriver, Jean Smith, Rose and Joseph Kennedy, the President-elect, Robert Kennedy, an eight-months-pregnant Jackie, Pat Lawford, Sargent Shriver (behind Ted Kennedy, seated), Joan Kennedy and Peter Lawford. Matriarch Rose wrote in her diary that JFK's political success came "because it is first a purely family team at the center."

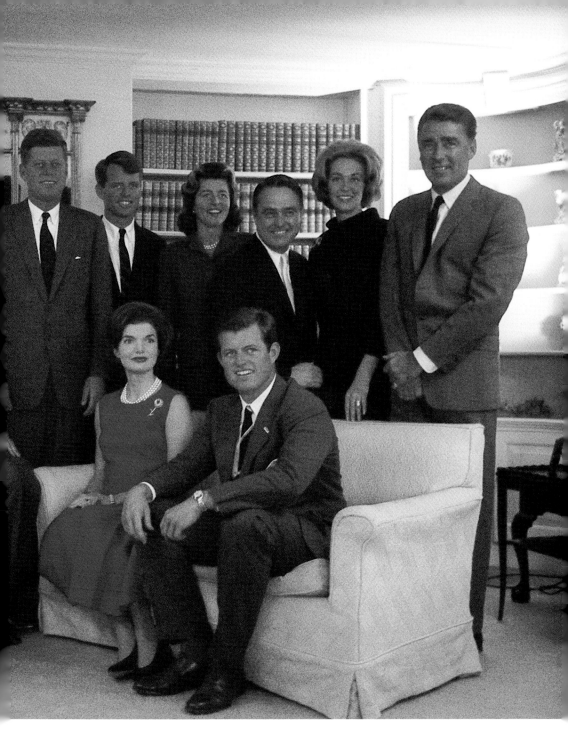

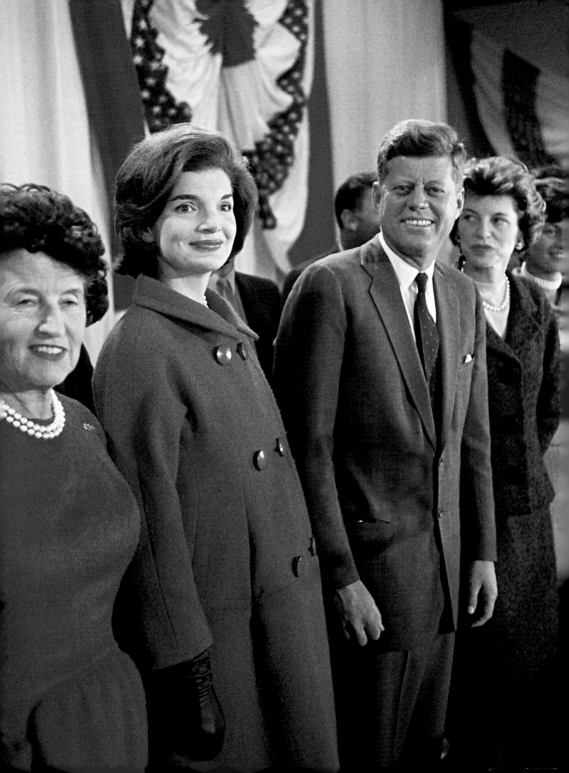

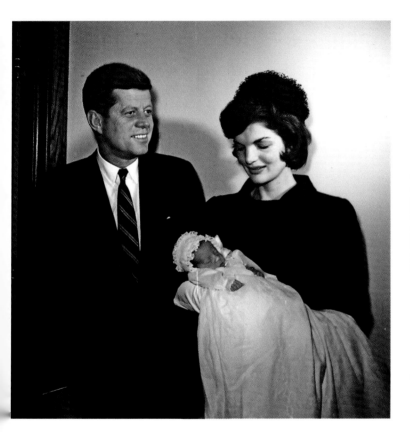

Wearing his father's 43-year-old christening gown, the month-premature boy, six pounds two ounces, was baptized in the chapel of Georgetown University Hospital in Washington, D.C. "Isn't he sweet, Jack?" the baby's mother said. "Look at those pretty eyes."

Following pages: John Jr.'s antics soon lit up the executive mansion. After a 1962 White House party he played with his mother's pearls, to her evident delight. "I was reading Carlyle," Jackie once explained, "and he said you should do the duty that lies nearest you. And the thing that lies nearest me is children."

"Will you be baptized, John Fitzgerald Kennedy Junior?"

—REV. MARTIN J. CASEY

Greeting the nation on the morning after Election Day, JFK began to plan Cabinet appointments. He was on his private plane, the *Caroline*, headed for Palm Beach to confer with advisers when his pregnant wife began hemorrhaging. "I'm never there when she needs me," he said, recalling Jackie's delivery of a stillborn girl four years earlier while he was in France. He went back to D.C.

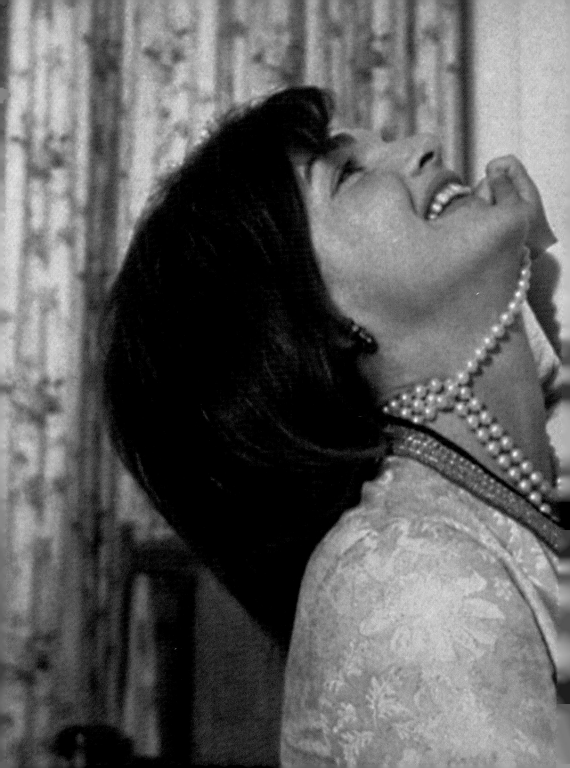

First Lady: The private person went grandly public and lifted the spirits of an entire nation.

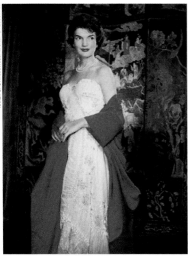

Jackie was America's most glamorous First Lady, a title she disliked for its "saddle horse" ring. "Would you notify the telephone operators," she once requested of a White House assistant, "that I'm to be known simply as Mrs. Kennedy?"

❝ 'All these people come to see the White House,' she said, 'and they see practically nothing that dates back before 1948. Every boy who comes here should see things that develop his sense of history. For the girls, the house should look beautiful and lived-in. They should see what a fire in the fireplace and pretty flowers can do for a house; the White House rooms should give them a sense of all that.

'Everything in the White House,' she says, 'must have a reason for being there. It would be sacrilege merely to "redecorate" it—a word I hate. It must be restored—and that has nothing to do with decoration. That is a question of scholarship.' ❞

FROM "EVERYTHING MUST HAVE A REASON FOR BEING THERE," BY HUGH SIDEY, IN LIFE, SEPTEMBER 1, 1961

Following pages:
The overlapping of political generations created an impressive lineup of dignitaries at the inaugural moment, including the four women here—from left, Pat Nixon, Mamie Eisenhower, Lady Bird Johnson and Jackie—who would together span 21 years of First Ladyship.

On January 20, 1961, Jackie was still weak from the birth of John Jr. two months earlier. Although she had been in and out of bed for days, she managed to attend one of the five inaugural balls (right).

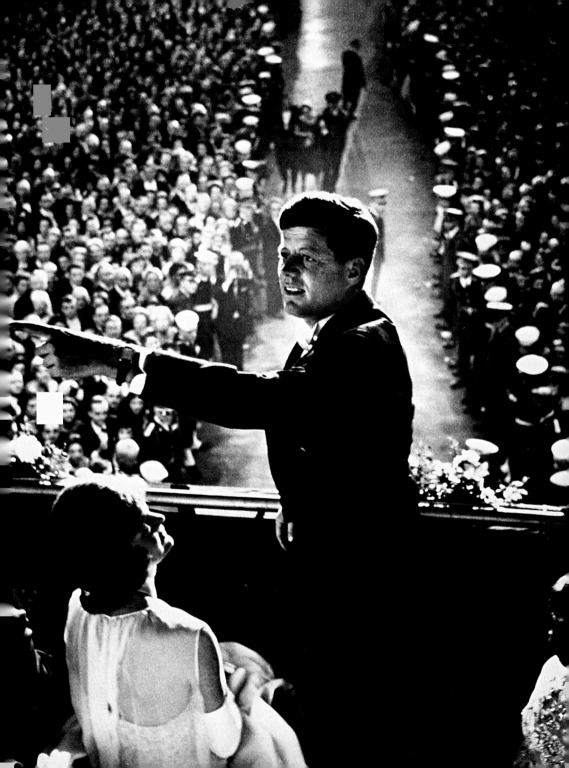

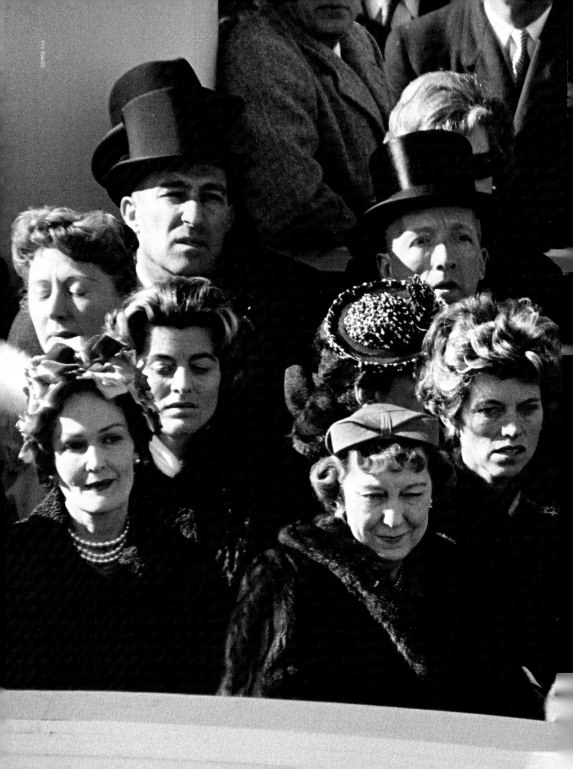

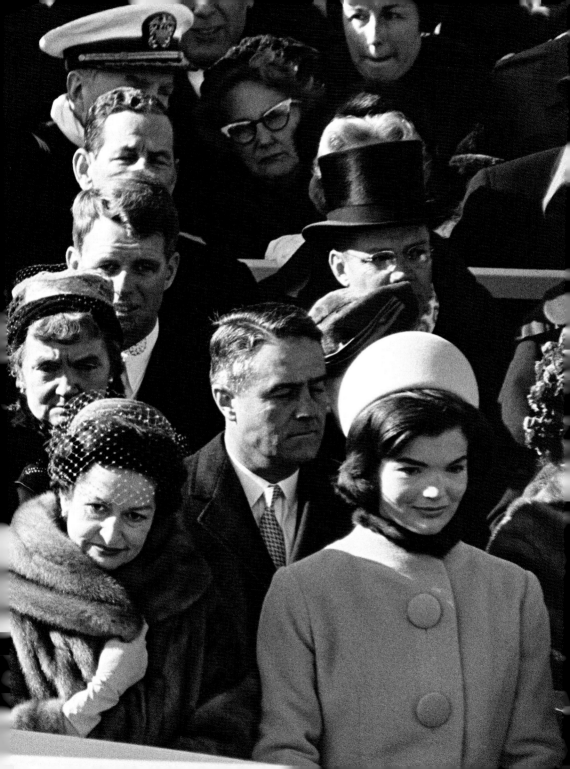

Jackie was at first disappointed with the White House. She referred to it as "that dreary Maison Blanche" and suggested that its shabby rooms made it look more like a run-down hotel than the home of the American President. Almost immediately, she set out to spruce things up, dreaming that when she was done, "De Gaulle would be ashamed of Versailles in comparison."

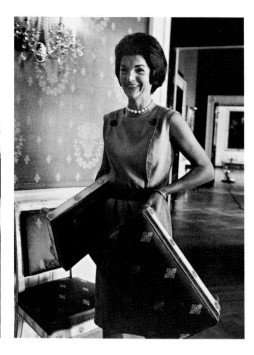

"We must make this building something they wil

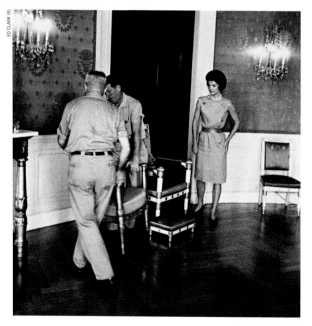

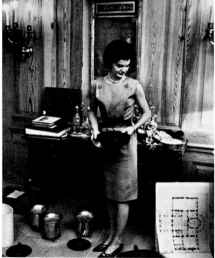

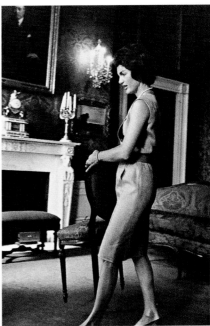

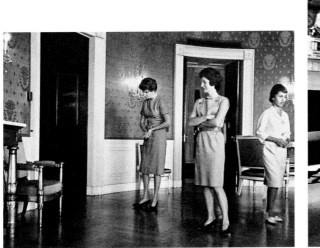

be proud of . . . the first house in the land."

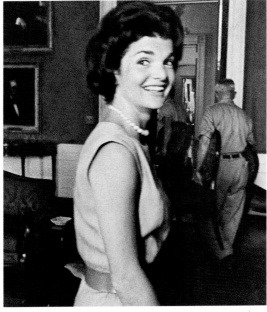

Jackie scoured the closets and basements of the old building in search of items discarded by previous tenants. The nation loved her campaign. And the traits that many had held against her—her expensive tastes and elegant manners—became political assets.

Following pages: The President's musical taste was limited to show tunes, but Jackie invited the world's finest classical artists to the White House. At one memorable state dinner, the 84-year-old Pablo Casals played.

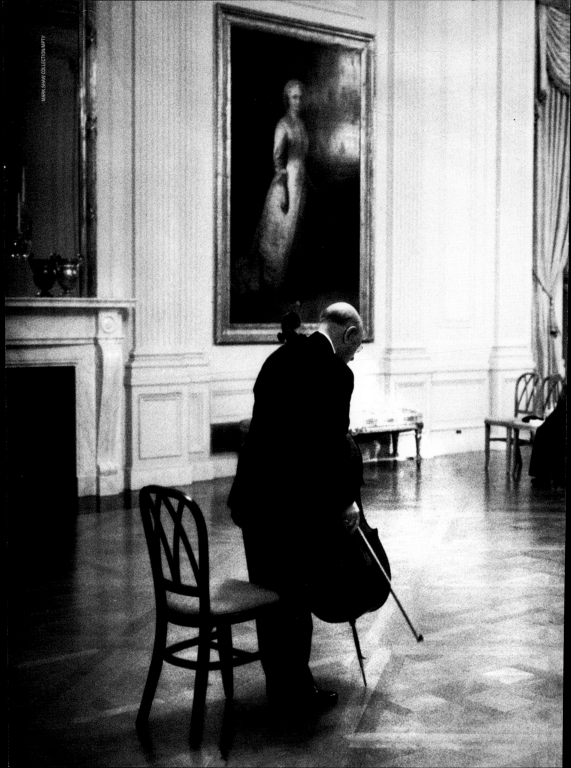

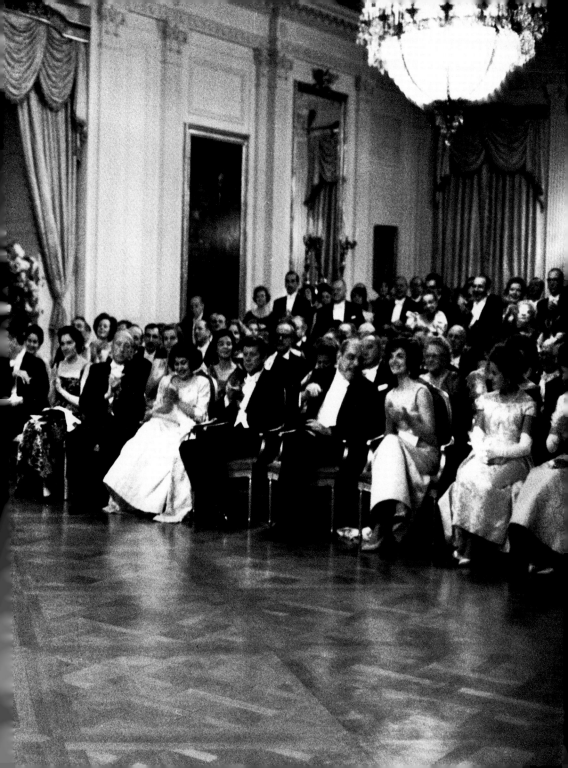

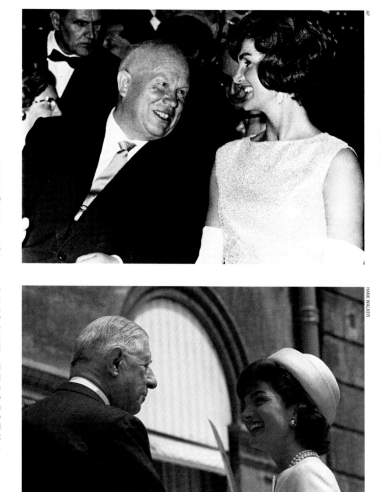

Nikita Khrushchev was unimpressed by President Kennedy when the two met in Vienna in 1961, but he couldn't keep his eyes off Jackie. With cameramen shouting for a picture of the two leaders shaking hands, Khrushchev pointed at Mrs. Kennedy and said, "I'd rather shake hands with her."

The presidential visit to Paris was Jackie's greatest international triumph. The local reporters compared her reception to that enjoyed by Queen Elizabeth. ("Queen Elizabeth, hell," said Kennedy aide Dave Powers. "They couldn't get this kind of turnout for the Second Coming.") Charles de Gaulle (right) was evidently so charmed by her that a cartoonist later drew the French president in bed with his wife but dreaming of Jackie.

"I am the man who accompanied Jacqueline Kennedy to Paris." —JFK

Following pages:
Mrs. Kennedy traveled not only with the President but also without him. In August 1962 she and Caroline visited the Ravello, Italy, summer home shared by Lee and her second husband, Prince Stanislas Radziwill (here, playing backgammon with an unidentified friend). Since it was a private vacation, the local police did their best to hold back the townspeople, but a little enthusiasm was permitted. "Mrs. Kennedy is very kind and one of the most beautiful women in the world," said an official. "Why shouldn't the Ravellesi cheer her?"

Jackie's first foreign trip as First Lady took her to Canada (right), where she prompted a member of the House of Commons to declare that "her charm, beauty, vivacity and grace of mind have captured our hearts."

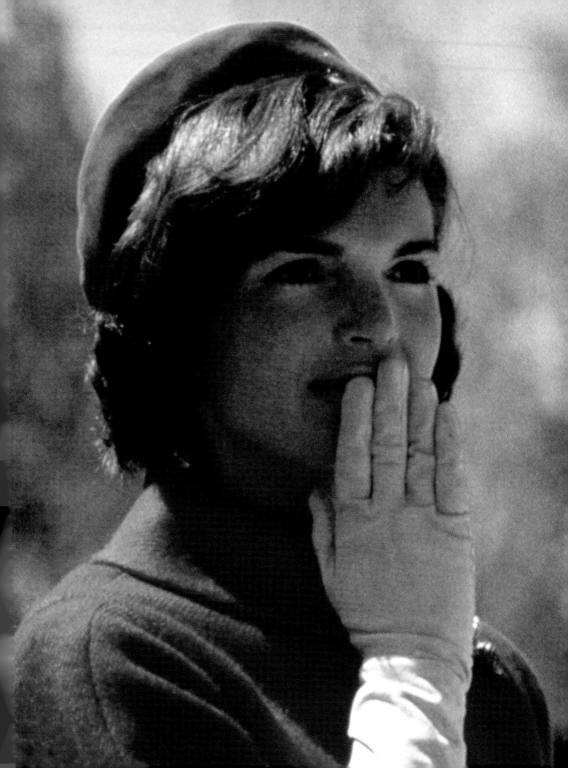

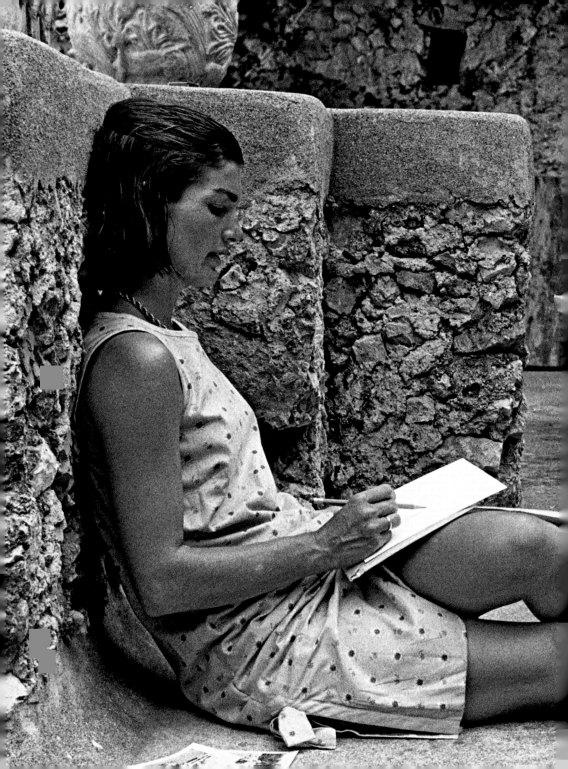

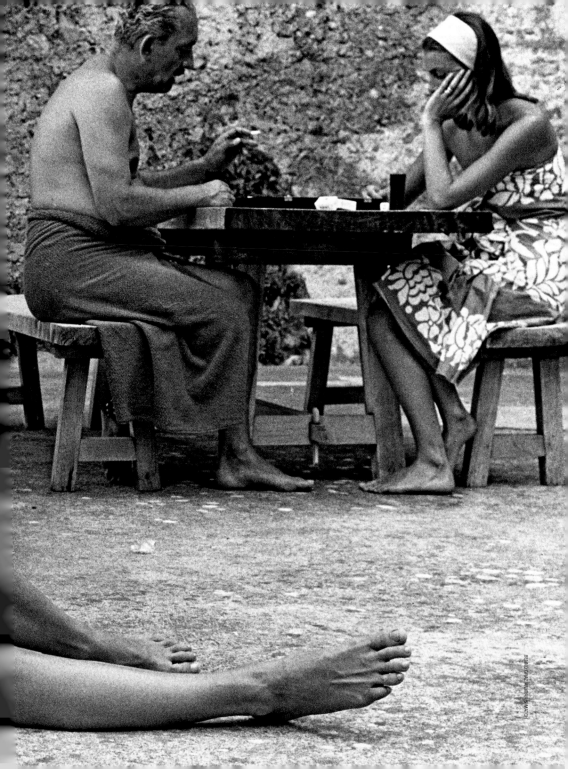

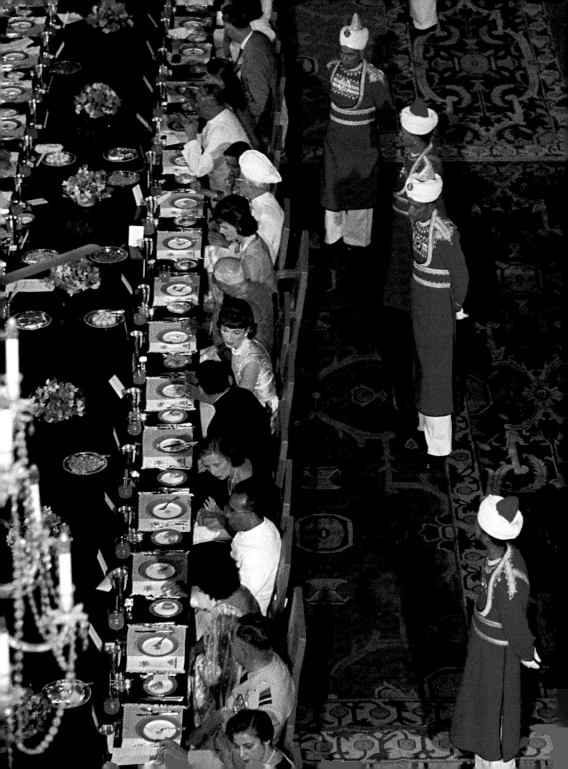

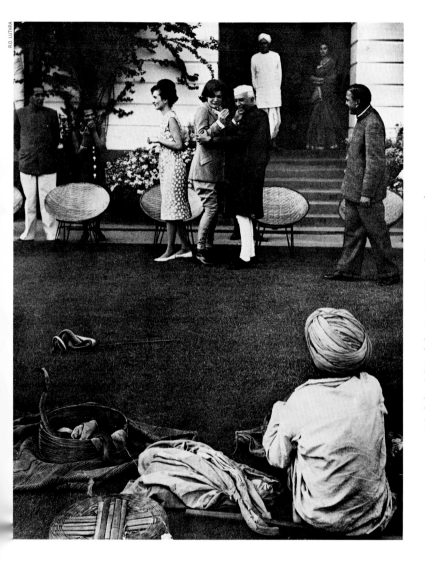

Jackie's legendary poise suffered a momentary jolt when a hungry cobra attacked near where she and Nehru were speaking. During Jackie's visit to India, the prime minister showered her with gifts, including two caged tiger cubs. "Can't we let them out?" she asked. Jackie's enthusiasm for Indian culture included a demand that she be allowed to celebrate *Holi*, a traditional festival involving the throwing of colored chalk powder. The Secret Service frowned on the idea, she said, "because they said the powder was made from manure. I said I didn't care, and I did it anyway."

Following pages:
While taking a rest from her Indian travels, with U.S. Ambassador John Kenneth Galbraith, she playfully turned her own miniature camera back on the prying eyes of the press corps.

In India for a 1962 visit, Jackie was received by noisy crowds who called her the *Ameriki Rani* (Queen of America). She was also quizzed mercilessly by journalists about the extensive range of clothing she brought to the subcontinent: 22 different outfits, including an elegant Oleg Cassini sheath that she wore to this luncheon with Prime Minister Nehru and 80 others in New Delhi.

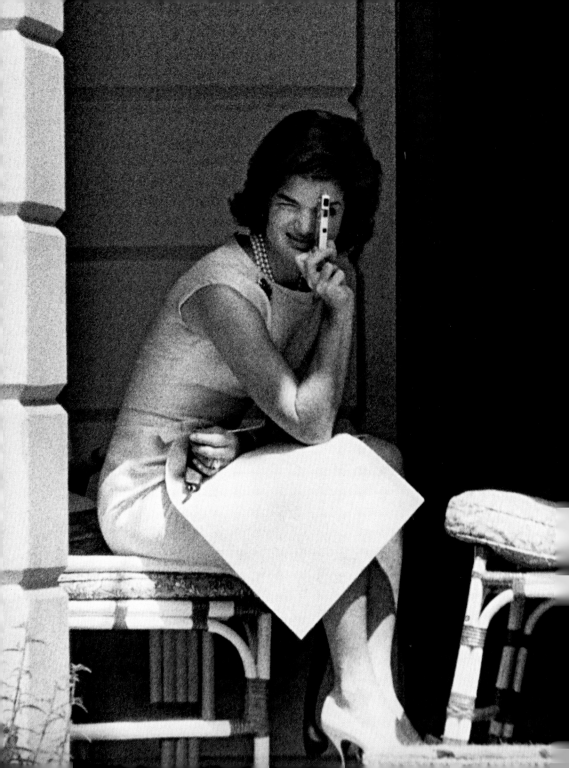

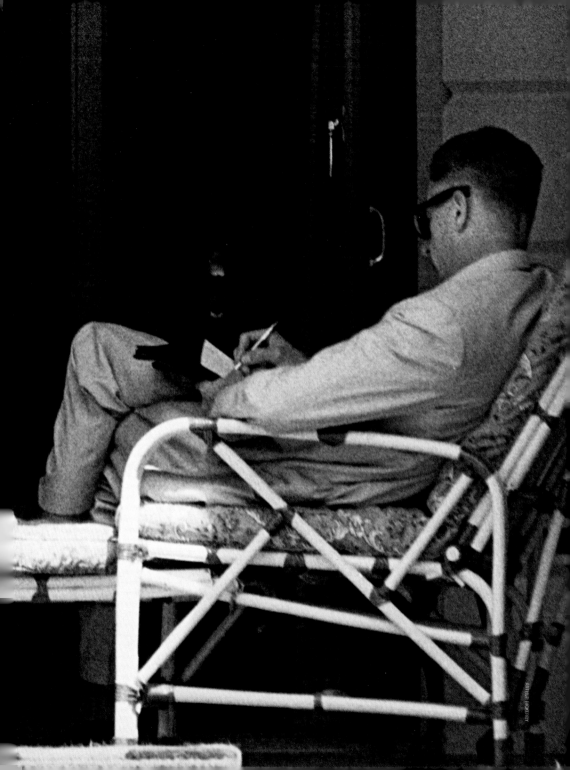

The Kennedy family ended up spending more time together in the White House than they had in Georgetown. Jackie gloated about the attention the children received from their father. "Sometimes they even have lunch with him," she said. "If you told me that would happen, I'd never have believed it. But . . . after all, the one thing that happens to a President is that his ties with the outside world are cut, and the people you really have are each other."

"She wanted the children to lead as normal lives as possible."

—ARTHUR M. SCHLESINGER JR.

Following pages:
In the winter of 1962, Jackie took her children and several of their friends for a sleigh ride around the South Lawn behind Caroline's pony, Macaroni. The scene, straight out of Currier & Ives, so delighted the Kennedys that it became the family Christmas card.

For the first time in decades, a President's young children had free run of the White House, and the nation was entranced. Shortly after learning how to walk, 18-month-old John made a cave of his father's desk (right). "I never want a house where you have to say to the children, 'Don't touch,'" Jackie said.

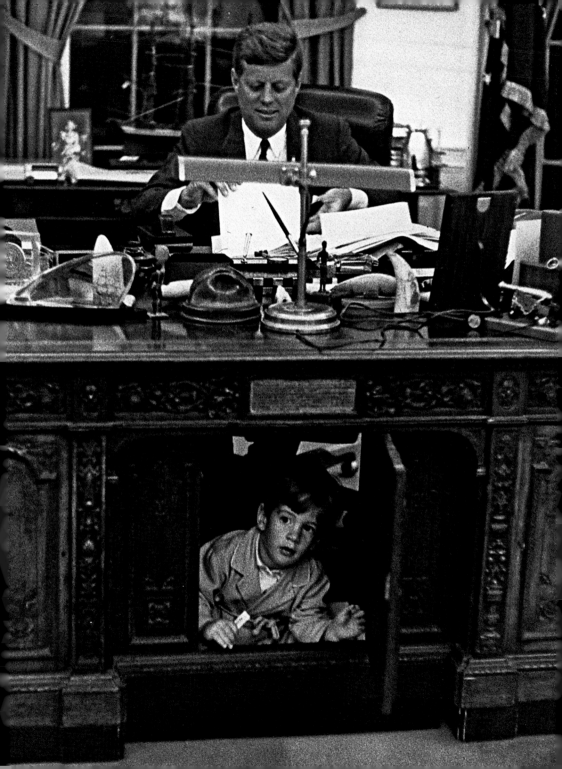

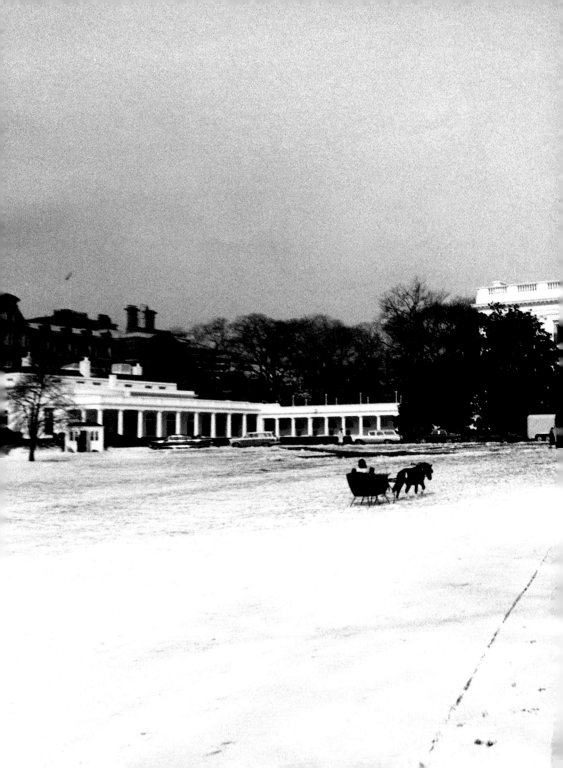

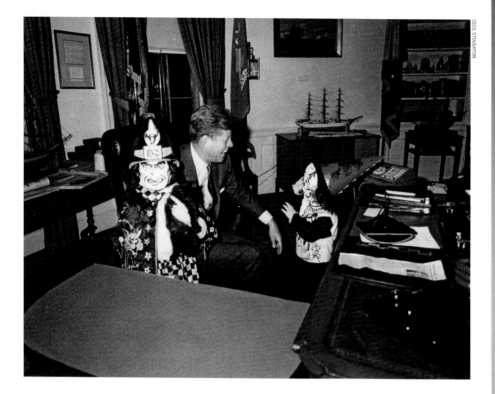

Late at night, on October 31, 1963, the sober work of a world leader was interrupted by a witch named Caroline and a goblin named John.

Whenever the President heard his children playing outside the Oval Office, he took a few moments to join in. One warm spring day in 1963, he made a tunnel for five-year-old Caroline.

Following pages:
In the summer of 1963 (when the dangers of smoking were not fully understood) a pregnant Jackie sailed off Hyannis Port while a nation awaited the first baby born to a President in office since 1895. But Jackie, who had a history of difficult pregnancies, had to be rushed to the hospital in August to give birth to a five-pound boy, five weeks premature. Patrick Bouvier Kennedy lived only 39 hours.

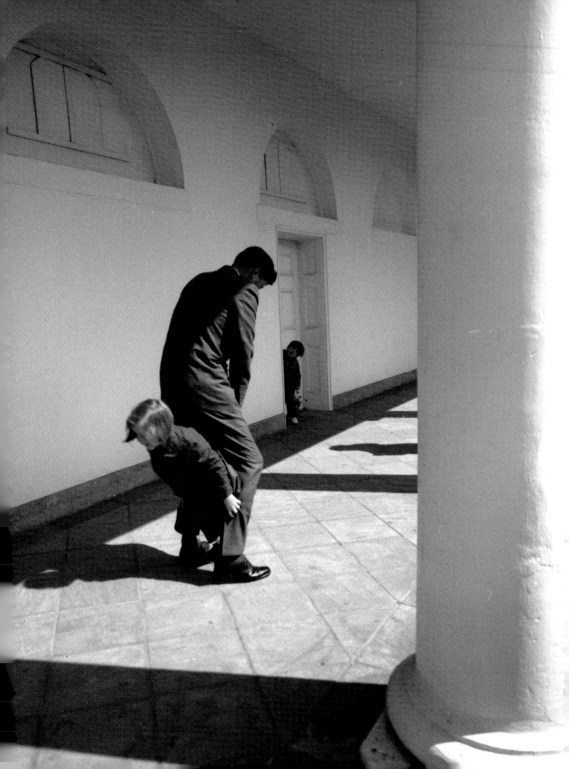

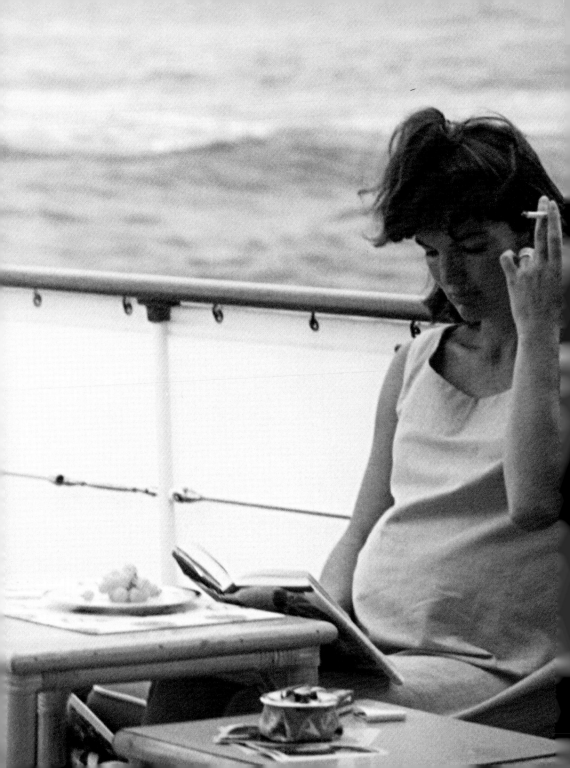

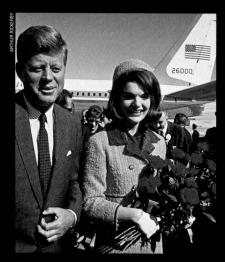

ARTHUR RICKERBY

"We're heading into nut country," he told Jackie prophetically before the plane landed. "But if somebody wants to shoot me, nobody can stop it."

" *Now in the sunny freshness of a Texas morning, with roses in her arms and a luminous smile on her lips, Jacqueline Kennedy still had one hour to share the buoyant surge of life with the man at her side.*

It was a wonderful hour. Vibrant with confidence, crinkle-eyed with an all-embracing smile, John F. Kennedy swept his wife with him into the exuberance of the throng at Dallas's Love Field. This was an act in which Jack Kennedy was superbly human. Responding to the warmth his own genuine warmth

evoked in others, he met his welcomers joyously, hand to hand and heart to heart. For him this was all fun as well as politics. For his shy wife, surmounting the grief of her infant son's recent death, this mingling demanded a grace and gallantry she soon would need again. Then the cavalcade, fragrantly laden with roses for everyone, started into town. Eight miles on the way, in a sixth-floor window, the assassin waited. All the roses were left to wilt. They would be long faded before a stunned nation would fully comprehend its sorrow. **"**

FROM "THE ASSASSINATION OF PRESIDENT KENNEDY," IN LIFE, NOVEMBER 29, 1963

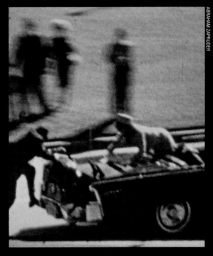

ABRAHAM ZAPRUDER

November 22, 1963: "Oh, no!" she cried as a Secret Service man leaped to protect her. Later, viewing frames from the Zapruder film, she said she had no memory of scrambling from her seat.

On *Air Force One*, en route to Washington, Lyndon B. Johnson took the oath of office. "Oh, Mrs. Kennedy, we never even wanted to be Vice President, and now, dear God, it's come to this," said Mrs. Johnson (left), shattered by the sight of Jackie's blood-caked clothing.

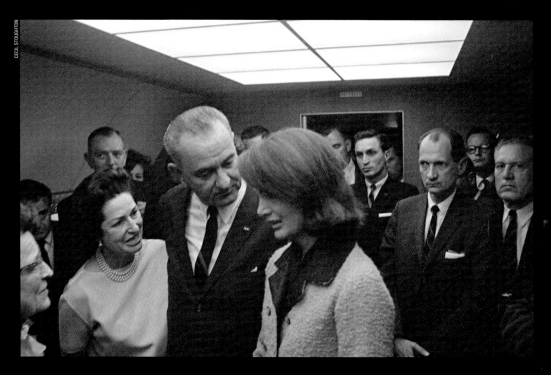

"No," she insisted, refusing to change out of her bloodstained suit. "I want them to see what they have done."

Robert Kennedy met the plane in Washington and clasped the widow's hand tightly as the bronze casket, hastily procured in Dallas, was unloaded. Jackie refused to sit in the front seat of the ambulance and rode in back with her husband's body.

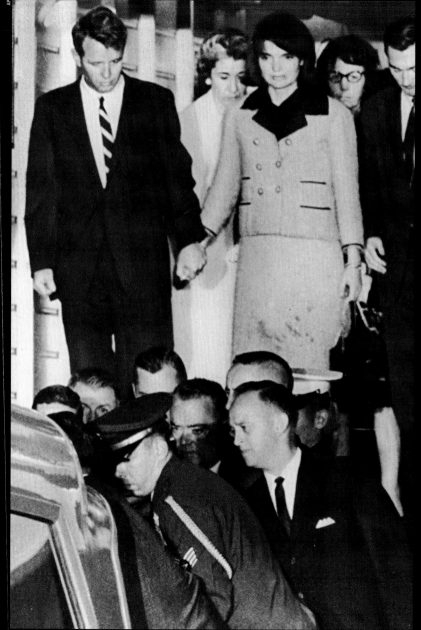

Following pages:
At Andrews Air Force Base, protocol chief Angier Biddle Duke asked Mrs. Kennedy, "How can I serve you?" She was ready with her reply: "Find out how Lincoln was buried." After lying in state in the White House on a catafalque duplicating Abraham Lincoln's, the President's body was moved to the Rotunda of the Capitol, where 250,000 people paid their respects. Then the widow, flanked by brothers-in-law Bobby and Ted, walked behind the coffin and the riderless horse to St. Matthew's Cathedral for the funeral mass.

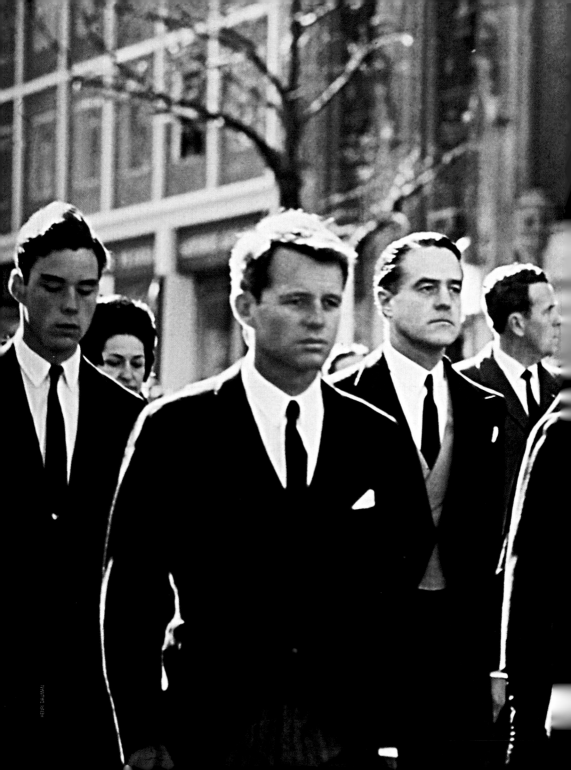

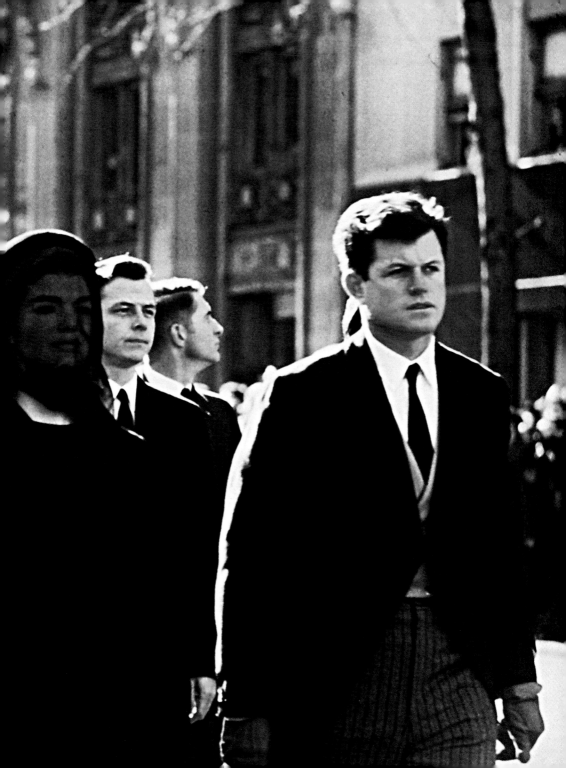

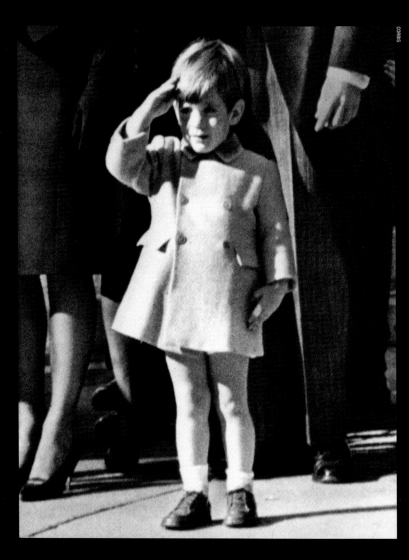

"John," she told her son as they stood outside S

The Monday of his father's funeral,
John turned three. His sister's sixth
birthday was two days later. They
celebrated the following week in
the White House. Their mother felt
that routine was crucial to their
well-being, and life went on as
usual. Said Caroline to one of her
friends, "I only cried twice."

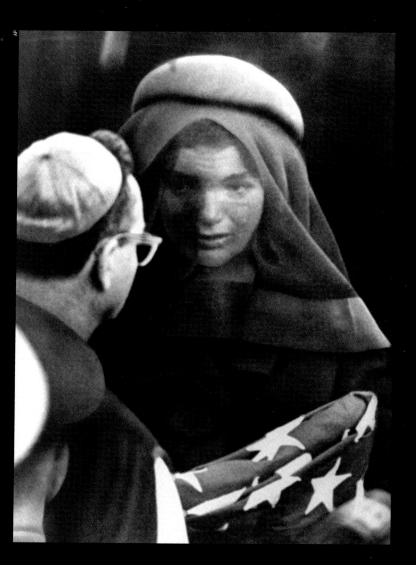 AP

Iatthew's, "you can salute Daddy now and say goodbye to him."

The honor guard handed the neat triangle of folded flag to the chief mourner. She lit the eternal flame, which she had wanted to represent "something living" at the site. She thanked officiating Bishop Philip Hannan (above) and departed. Late that night, when her official life was done, she returned to the grave to leave a sprig of lily of the valley.

She remembers how hot the sun was in Dallas, and the crowds—greater and wilder than the crowds in Mexico or in Vienna. The sun was blinding, streaming down; yet she could not put on sunglasses for she had to wave to the crowd.

And up ahead she remembers seeing a tunnel around a turn and thinking that there would be a moment of coolness under the tunnel. There was the sound of motorcycles, as always in a parade, and the occasional backfire of a motorcycle. The sound of the shot came, at that moment, like the sound of a backfire, and she remembers Connally saying, "No, no, no, no, no . . ."

She remembers the roses. Three times that day in Texas they had been greeted with the bouquets of yellow roses of Texas. Only, in Dallas they had given her *red* roses. She remembers thinking, how funny—red roses for me; and then the car was full of blood and red roses.

Much later, accompanying the body from the Dallas hospital to the airport, she was alone with Clint Hill—the first Secret Service man to come to their rescue—and with Dr. Burkley, the White House physician. Burkley gave her two roses that had slipped under the President's shirt when he fell, his head in her lap.

All through the night they tried to separate him from her, to sedate her, and take care of her—and she would not let them. She wanted to be with him. She remembered that Jack had said of his father, when his father suffered the stroke, that he could not live like that. Don't let that happen to me, he had said, when I have to go.

Now, in her hand she was holding a gold St. Christopher's medal.

She had given him a St. Christopher's medal when they were married; but when Patrick died this summer, they had wanted to put something in the coffin with Patrick that was from them both; and so he had put in the St. Christopher's medal.

Then he had asked her to give him a new one to mark their 10th wedding anniversary, a month after Patrick's death.

He was carrying it when he died, and she had found it. But it belonged to him—so she could not put *that* in the coffin with him. She wanted to give him something that was hers, something that she loved. So she had slipped off her wedding ring and put it on his finger. When she came out of the room in the hospital in Dallas, she asked: "Do you think it was right? Now I have nothing left." And Kenny O'Donnell said, "You leave it where it is."

That was at 1:30 p.m. in Texas.

But then, at Bethesda Hospital in Maryland, at three a.m. the next morning, Kenny slipped into the chamber where the body lay and brought her back the ring, which, as she talked now, she twisted.

On her little finger was the other ring: a slim, gold circlet with green emerald chips—the one he had given her in memory of Patrick.

There was a thought, too, that was always with her. "When Jack quoted something, it was usually classical," she said, "but I'm so ashamed of myself—all I could keep thinking of is this line from a musical comedy.

"At night, before we'd go to sleep, Jack liked to play some records; and the song he loved most came at the very end of this record. The lines he loved to hear were: *Don't let it be forgot/that once there was a spot/for one brief shining moment that was known as Camelot.*"

She wanted to make sure that the point came clear and went on: "There'll be great Presidents again—and the Johnsons are wonderful, they've been wonderful to me—but there'll never be another Camelot again.

"Once, the more I read of history, the more bitter I got. For a while I thought history was something that bitter old men wrote. But then I realized history made Jack what he was. You must think of him as this little boy, sick so much of the time, reading in bed, reading history, reading the Knights of the Round Table, reading Marlborough. For Jack, history was full of heroes. And if it made him this way—if it made him see the heroes—maybe other little boys will see. Men are such a combination of good and bad. Jack had this hero idea of history, the idealistic view."

But she came back to the idea that transfixed her: *Don't let it be forgot/that once there was a spot/for one brief shining moment that was known as Camelot*—and it will never be that way again.

As for herself? She was horrified by the stories that she might live abroad. "I'm never going to live in Europe. I'm not going to 'travel extensively abroad.' That's desecration. I'm going to live in the places I lived with Jack. In Georgetown, and with the Kennedys at the Cape. They're my family. I'm going to bring up my children. I want John to grow up to be a good boy."

As for the President's memorial, at first she remembered that in every speech in their last days in Texas, he had spoken of how in December this nation would loft the largest rocket booster yet into the sky, making us first in space. So she had wanted something of his there when it went up—perhaps only his initials painted on a tiny corner of the great Saturn, where no one need even notice it. But now Americans will seek the moon from Cape Kennedy. The new name, born of her frail hope, came as a surprise.

The only thing she knew she must have for him was the eternal flame over his grave at Arlington.

"Whenever you drive across the bridge from Washington into Virginia," she said, "you see the Lee mansion on the side of the hill in the distance. When Caroline was very little, the mansion was one of the first things she learned to recognize. Now, at night you can see his flame beneath the mansion for miles away."

She said it is time people paid attention to the new President and the new First Lady. But she does not want them to forget John F. Kennedy or read of him only in dusty or bitter histories:

For one brief shining moment there was Camelot.

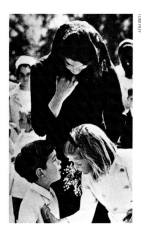

Jackie tried to shelter her two fatherless children from the burdens of grief. But she never let them forget the President and often asked old Kennedy confidants over for dinner to tell Caroline and John stories about Jack. On what would have been the President's 47th birthday, Jackie and her children visited the grave. Jackie left a spray of lilies of the valley; John Jr., a tie clasp shaped like PT 109.

Two months after that tragic day, Jackie appeared on television to thank all those who had offered their sympathy.

I want to take this opportunity to express my appreciation for the hundreds of thousands of messages . . . which my children and I have received over the past few weeks.

The knowledge of the affection in which my husband was held by all of you has sustained me, and the warmth of these tributes is something I shall never forget. Whenever I can bear to, I read them. All his bright light gone from the world. All of you who have written to me know how much we all loved him and that he returned that love in full measure.

It is my greatest wish that all of these letters be acknowledged. They will be, but it will take a long time to do so . . . I know you will understand.

Each and every message is to be treasured, not only for my children, but so that future generations will know how much our country and people in other nations thought of him. Your letters will be placed with his papers in the library to be erected in his memory. I hope that in years to come many of you and your children will be able to visit the Kennedy Library. It will be, we hope, not only a memorial . . . but a living center of study . . . for young people and for scholars from all over the world.

May I thank you again on behalf of my children and of the President's family for the comfort that your letters have brought to us all.

In May 1964 she announced the opening of a touring exhibit of President Kennedy's mementos that she had put together to raise funds for the John Fitzgerald Kennedy Library and Museum, which opened in Boston in 1979.

Fallen Idol: Her surprising new love was too short, too rich, too foreign—and he wasn't Jack.

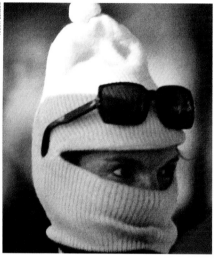

HARRY BENSON

In February 1968, on a family ski trip in Canada, she appeared content. But after Robert Kennedy's assassination in June, she swiftly set marriage plans in motion. "If they're killing Kennedys, my children are the number one targets. I want to get out of this country."

"A great deal has been said during the last few days about the martyred heroine of Camleot whose image was shattered when Jackie's social secretary broke the news in that absurdly formal statement: 'Mrs. Hugh Auchincloss has asked me to tell you that her daughter, Mrs. John F. Kennedy, is planning to marry . . .' Cabdrivers have volunteered their opinion by the thousands: 'She don't need the money . . . she must be nuts!' So has the great American housewife. 'I feel almost as badly,' said a helpmeet in Atlanta, 'as when Jack was assassinated.' 'German women saw a halo around her head,' said an editor of Hamburg's illustrated weekly, Stern, *'but now it is gone with the wind.'"*

FROM "FOR THE BEAUTIFUL QUEEN JACQUELINE, GOODBY CAMELOT, HELLO SKORPIOS," BY PAUL O'NEIL, IN LIFE, NOVEMBER 1, 1968

The 5'7" Jackie and 5'5" Aristotle Onassis attended a Park Avenue party in 1971. Onassis had been a guest at the Kennedy White House.

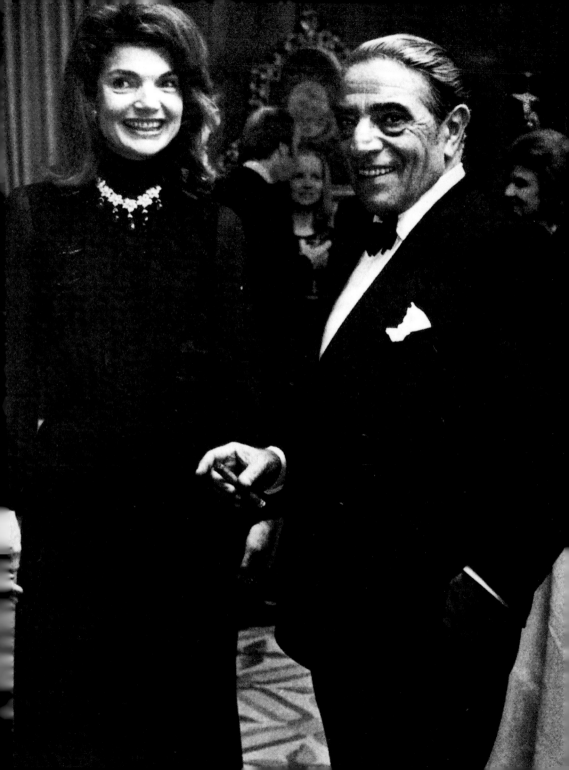

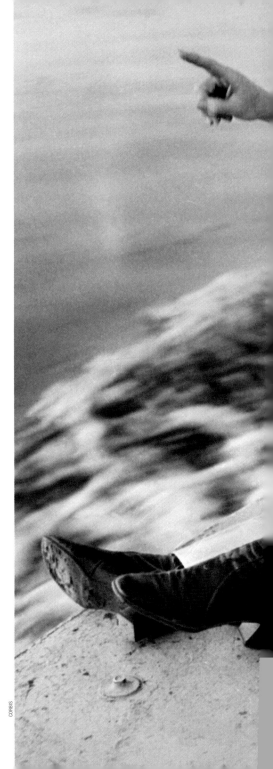

Teddy Kennedy began the prenuptial negotiations that resulted in Jackie's saying "I do" at $1.5 million per word. At first, as Rose Kennedy (above, right) joined the pair on Skorpios, it seemed like one big happy family. But soon Onassis minions were, according to some sources, using the code name Supertanker to refer to the new Mrs.: She was that costly an acquisition.

Questions about the Onassis marriage arose when he was seen squiring former mistress Maria Callas in Paris while his wife found other escorts in New York. "Jackie is a little bird," he responded. "She can do exactly as she pleases—visit international fashion shows and travel and go out with friends to the theater or anyplace. And I, of course, will do exactly as I please." In 1972 they "pleased" to celebrate their fourth wedding anniversary at a New York club (arriving by limo, **previous pages**), and in 1974 the two vacationed on a riverboat on the Nile (right). But in the months before Onassis's death the next year, they were hardly seeing each other. And the union that had been consecrated with a ruby-encrusted wedding band on Skorpios on October 20, 1968, ended with a settlement in excess of $20 million from the Onassis estate.

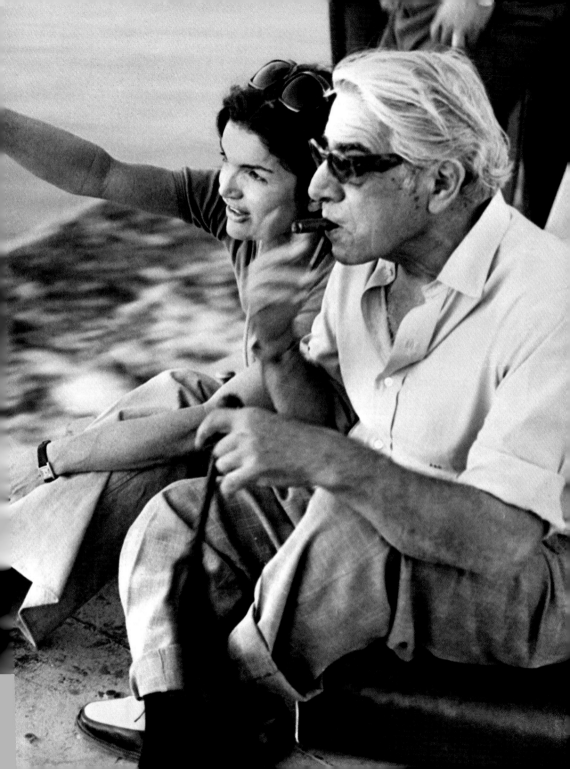

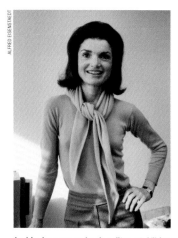

Jackie became a book editor at Viking Press in 1975 but left when Viking published a Jeffrey Archer novel that imagined an assassination plot against Ted Kennedy. In 1978 she joined Doubleday.

❝At issue is whether the woman below, whom most of the world instantly recognizes as Jacqueline Kennedy Onassis, is a private person, as she insists. Or is she a global celebrity whose every footstep is a legitimate news event? . . . Jackie's case is built in large part on the notion that, her supercelebrity status aside, she has the right to be left alone in public. But it seems doubtful that Mrs. Onassis can ever hope to enjoy real anonymity. During her days on the witness stand the courtroom was jammed. As soon as she had finished testifying, most of the spectators left.❞

FROM "ONE MAN'S RUNNING BATTLE WITH JACKIE,"
IN LIFE, MARCH 31, 1972

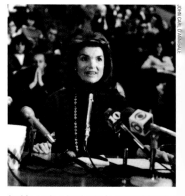

Jackie took a lead role in several battles to save New York City landmarks. She appeared in Albany in 1984 to plead for the protection of an endangered church.

At the 1986 wedding of niece Maria Shriver and film star Arnold Schwarzenegger, the crowd turned its attention toward Jackie, who hurriedly closed her limousine window and sped out of view.

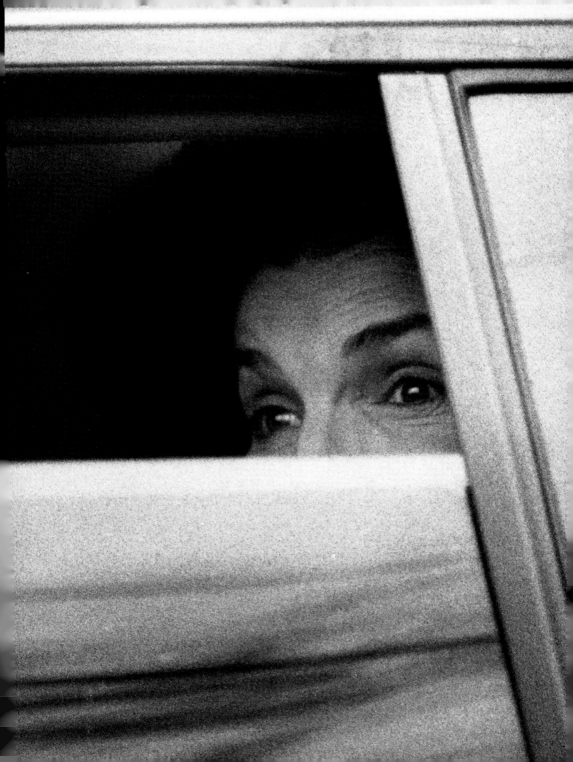

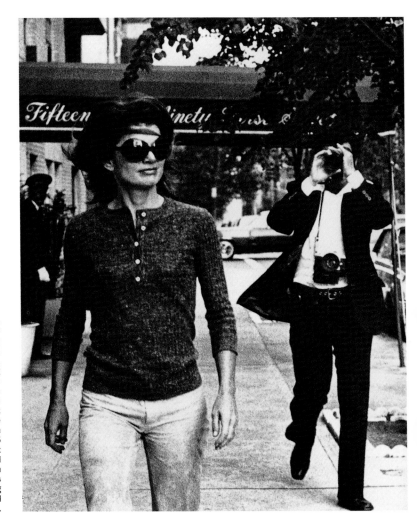

Trying to lead a private life in the most public of cities, Jackie assumed disguises and took Central Park strolls after dark, but there was no resisting the unrelenting intrusions of paparazzo Ron Galella (right, with camera). In 1973 she won a court ruling against the photographer, and Galella was ordered to stay 25 feet from her and 30 feet from her children. He had already taken more than 4,000 pictures of his beleaguered prey, including the frequently reprinted one on the opposite page.

"No peace, no peace of mind . . . imprisonment in my own house."

—FROM JACKIE'S COURT TESTIMONY

Following pages: Water remained a favorite refuge. Whether aboard Onassis's yacht in the 1970s or, years later, that of her companion Maurice Tempelsman, Jackie felt protected by the sea. Here, she reacts to a gust of wind in New York Harbor

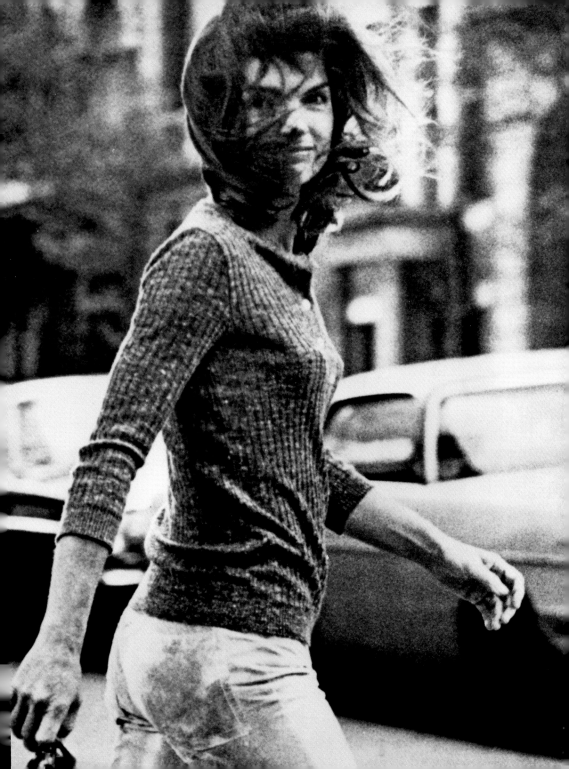

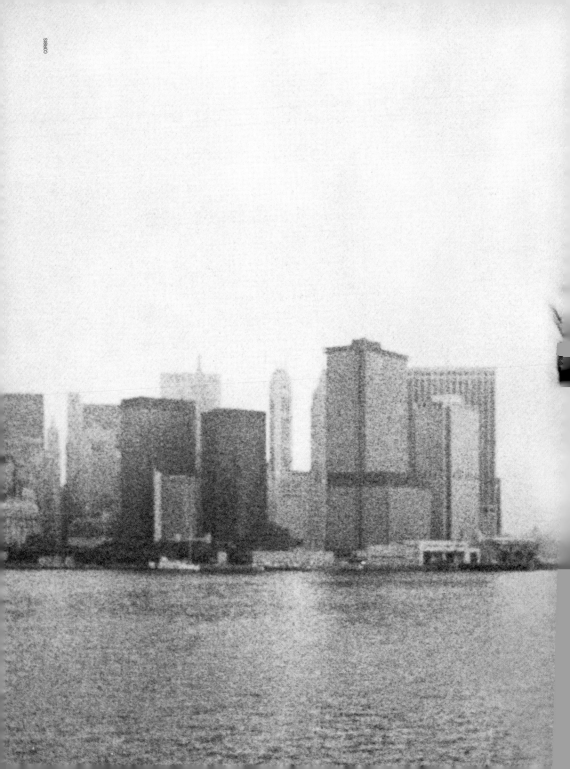

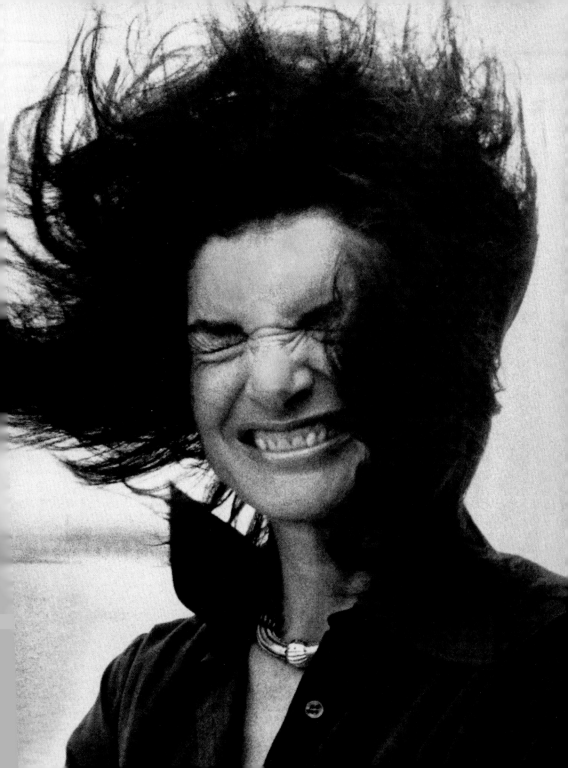

Matriarch: Of all the roles she played so well, she was loved most for the one she loved best.

With diamond merchant Maurice Tempelsman, at the 1990 unveiling of a JFK statue. He spent more years with her than did either spouse.

“ *No one else looked like her, spoke like her, wrote like her or was so original in the way she did things. No one we knew ever had a better sense of self.*

Her two children turned out to be extraordinary, honest, unspoiled and with a character equal to hers. They are her two miracles. She once said that 'if you bungle raising your children, nothing else much matters in life.' She didn't bungle. Once again, she showed how to do the most important thing of all, and do it right.

Jackie was too young to be a widow in 1963, and too young to die now. Her grandchildren were bringing new joy to her life, a joy that illuminated her face whenever you saw them together. In truth, she did everything she could, and more, for each of us. ”

FROM THE EULOGY BY SEN. EDWARD M. KENNEDY.
MAY 23, 1994

Caroline's eldest child, Rose Kennedy Schlossberg entertained her grandmother in 1992

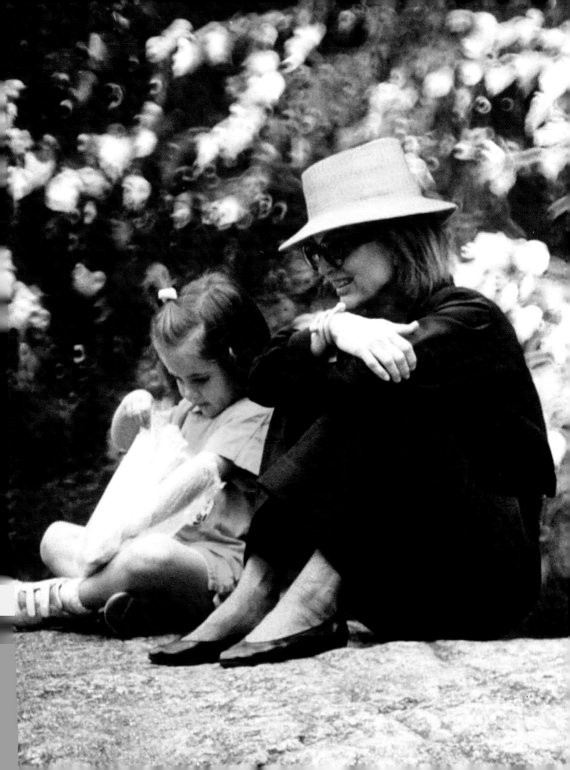

When ground was broken for the Kennedy Library in 1977, the extended clan (joined by Massachusetts Gov. Michael Dukakis, second from right) was there to revel in a celebration that recalled a favorite Kennedy line from Tennyson: "Tho' much is taken, much abides. . ."

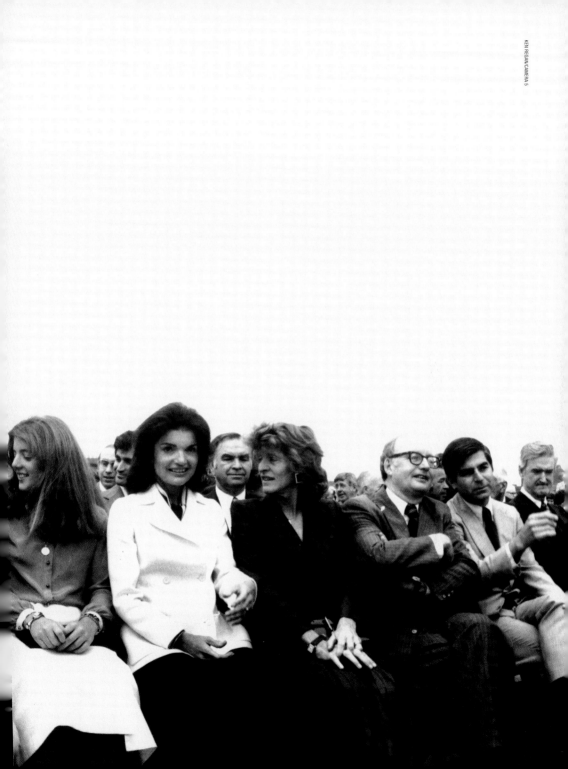

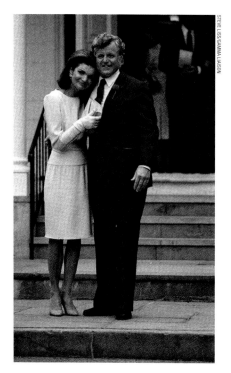

Her relationship with the
last surviving Kennedy
brother remained close until
the end. At Caroline's
wedding in 1986, Edward M.
Kennedy called his sister-
in-law "that extraordinary,
gallant woman."

Every year, Jackie hosted a
Kennedy family weekend on
her 375-acre Martha's
Vineyard estate. On this
golden day of her last
summer, she managed to
steal a quiet moment with
her daughter—away from
her guests, who included
Bill and Hillary Clinton.

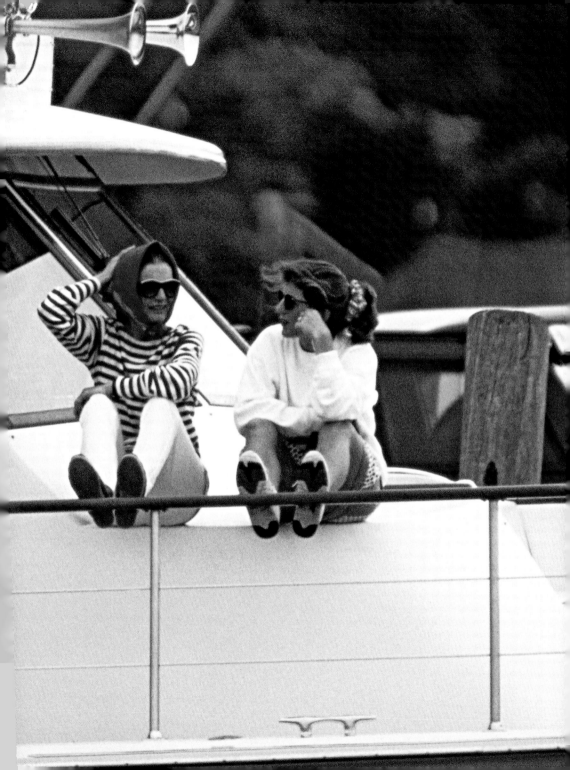

Delighted as she was to see her daughter happily settled with Edwin Schlossberg, Jackie left one bit of unfinished family business. She had yet to see her son John (here, at the Kennedy Library awards ceremony in Boston) marry. At Jackie's death, John and his sister, along with Caroline's three children, stood as her heirs—in spirit as well as in law.

It was the final major trip
of her life, and the
destination, appropriately,
was her beloved France.
In 1993, Jackie and
Tempelsman vacationed
near Arles, in the Rhône
Valley. He wanted to visit
the caves he remembered
from a childhood
excursion; she hoped to
visit Pont-Saint-Esprit,
a village important to her
Bouvier ancestors.

LUCIEN CLERGUE

In New York City's Grand Central Terminal on the Monday after Mrs. Onassis's death, mourners lined up to inscribe their names and thoughts in a pair of memorial books. She had been the most prominent, and most effective, advocate of the building's preservation.

"With admiration, love and gratitude, for all the inspiration and the

dreams she gave to all of us, we say goodbye to Jackie today."
—President Clinton, May 23, 1994

A

case of love at first sight—that's really the only way to describe it. LIFE and Jacqueline Kennedy met in July 1953, and from that time to the end of her life we wooed her with a passion and persistence unmatched by any other publication. She was born to be photographed, and LIFE was the first publication to recognize that not insignificant fact of 20th century life. But it took us a while, as it took the world a while, to understand that Jackie was far more than a unique and

magical face. LIFE was the first national magazine to put her on its cover, and over the years, as public fascination persisted and our awareness of her deeper qualities grew, we gave her the cover 18 times in all—a number unrivaled by any other LIFE subject except her husband. Not all our articles were uncritical, and neither were her responses, but the relationship lasted. (Time has not always been as kind to the way we described her and the way she talked about herself: As some of the quotations in this book demonstrate, journalistic language can rapidly become archaic.)

Our romance with Jackie got off to a lively start. On a sunny July day at Hyannis Port, Hy Peskin took some knock-your-socks-off pictures of the radiant young woman Jack Kennedy had just decided to marry. Two months later, Lisa Larsen shot their wedding for us. And in 1959, when Caroline was nearly two, Mark Shaw caught Jackie, Jack and their little girl in frames that glow with young love and family happiness.

One Sunday afternoon, not long after Jackie became First Lady, the phone rang at the home of Hugh Sidey, LIFE's White House correspondent. "Hugh, it's the President. Jackie wants to talk to you." Jackie came on the line. "Hugh, I really want to make the White House like it was, like it was meant to be." The problem, she said, was money. "I've got to get a fund going, and I have an idea. I'll write a piece for LIFE and you can pay me some money."

And that's how Jackie's historic renovation of the White House began. LIFE put up $50,000, then waited for Jackie to deliver her article. And waited. Sidey kept calling the White House; Jackie never called back. Twice Sidey flew to Hyannis Port; twice he waited there all weekend without a word from Jackie. So he went on vacation—and, inevitably, she traced him to Nebraska and sweetly asked if he'd mind flying back to Hyannis Port. When he arrived, six months after the piece had

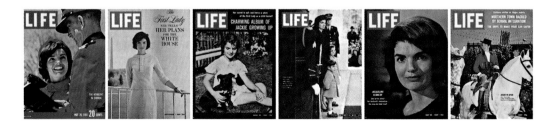

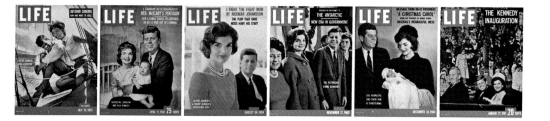

been assigned, she knelt on the floor and shyly unrolled a 12-foot-long manuscript made of yellow ruled sheets stuck together with Scotch tape. "It looked like the Dead Sea Scrolls," Sidey remembered later, "and, to be honest, it wasn't very good." A tactful editor named Russ Sackett nudged the article into shape, and it appeared in the September 1, 1961, issue. "Piece cost too damn much," managing editor Ed Thompson grumbled at the time, but today $50,000 seems a small price to pay for a share in the White House Jackie left us.

LIFE covered the tragedy in Dallas with skill and daring. Correspondent Dick Stolley tracked down Abraham Zapruder and acquired his 8mm movie of the assassination. LIFE's readers were the first to see the tragedy unfold instant by instant. But Jackie said nothing about the nightmare she had endured—until she told her story to LIFE. She summoned LIFE's greatest reporter, Teddy White, to Hyannis Port and relived the horror in ghastly detail: "I could see a piece of his skull coming off . . . His blood and his brains were in my lap . . . and I kept saying . . . , 'Jack, Jack, can you hear me, I love you, Jack' . . . But I knew he was dead." LIFE spared its stunned readers some of her more shocking memories, which White would later expand upon in his book *In Search of History*. Instead, the magazine concentrated on her wistful recollection that Jack as a boy had loved reading about King Arthur, and that his favorite music was the final refrain of *Camelot*. Sensing the symbolic resonance of Alan Jay Lerner's lyrics—"Don't let it be forgot/that once there was a spot/for one brief shining moment that was known as Camelot"—White used them as a leitmotiv in the story he dictated from a phone in Jackie's kitchen to LIFE's assistant managing editor Ralph Graves.

It was in White's article, which appeared in our December 6, 1963, issue and is reprinted in this volume, that the Kennedy era was first described as Camelot.

The following year Jackie called LIFE again. She asked us to do a story about an exhibit of her husband's belongings, and we agreed—with one proviso: Jackie had to appear in the pictures. She did, and Dick Stolley wrote a graceful piece about the mementos. Later he attended the opening of the exhibit. "When she heard my name," he remembers today, "she fixed those glowing brown orbs on me, and in that breathless voice she said, 'Oh, Mr. Stolley, that was such a wonderful article. I am so deeply in debt to you.' And I have to tell you, my heart was pounding. She was a woman of rare beauty and presence—there really was an aura about her."

In later years, one of Jackie's closest associates at the magazine was contributing photographer Harry Benson. He photographed Jackie's children for a LIFE story, and at her request he shot Caroline's wedding for us too. The wedding pictures, which Jackie loved, cemented a friendship in which Benson found her "surprisingly open, not at all guarded."

Lastly, in April 1994, Jackie met with LIFE senior editor Steve Petranek and director of photography David Friend to show them a new collection of photographs. She was very thin, they reported back at the office, but seemed vibrant and vital. She served her visitors lunch, showed them the photographs, then quietly took her leave. Two days later she checked into New York Hospital. Six weeks after that she was dead. Her last business appointment was the meeting with LIFE.

—THE EDITORS

Memory of Cape Cod

by Edna St. Vincent Millay

The wind in the ash-tree sounds like surf on the shore at Truro.
I will shut my eyes . . . hush, be still with your silly bleating,
 sheep on Shillingstone Hill . . .

They said: Come along! They said: Leave your pebbles on the sand and come
 along, it's long after sunset!
The mosquitoes will be thick in the pine-woods along by Long Nook, the wind's
 died down!
They said: Leave your pebbles on the sand, and your shells, too, and come along,
 we'll find you another beach like the beach at Truro.

Let me listen to wind in the ash . . . it sounds like surf on the
 shore.

—ONE OF JACQUELINE KENNEDY ONASSIS'S
FAVORITE POEMS,
RECITED BY CAROLINE KENNEDY SCHLOSSBERG
AT HER MOTHER'S FUNERAL,
MAY 23, 1994